IMAGES
of America

DOWNTOWN
VANCOUVER

ON THE COVER: The Woodmen of the World band poses in the bandstand at Esther Short Park in 1905.

IMAGES
of America

DOWNTOWN
VANCOUVER

Pat Jollota

ARCADIA

Published by Arcadia Publishing
Charleston SC, Chicago IL, Portsmouth NH, San Francisco CA

Printed in Great Britain

Library of Congress Catalog Card Number: 2004112272

For all general information contact Arcadia Publishing at:
Telephone 843-853-2070
Fax 843-853-0044
E-mail sales@arcadiapublishing.com
For customer service and orders:
Toll-Free 1-888-313-2665

Visit us on the internet at http://www.arcadiapublishing.com

CONTENTS

ACKNOWLEDGMENTS

Many wonderful people helped in putting this book together; such a project can never be accomplished alone. My good friend Cynthia Phelps was a rock of Gibraltar, offering both moral support and computer expertise. I am deeply grateful to her husband, Steve, who let me monopolize her time. David Fenton, the former director of the Clark County Historical Museum, took time off to come and help and shortened an impossibly long tale into manageable size. Kathy Klingler, curator of the Clark County museum, not only helped pull the images, but helped in refiling them, a difficult job that is often overlooked. Christopher Storz, a volunteer at the museum, jumped in without asking, and could find images that no one else could. Cecelia Colson also helped to find images, and kept me laughing.

Virtually all of the photographs in this book are from the collection of the Clark County Historical Museum, which is located in the 1910 Carnegie Library at 1511 Main Street in downtown Vancouver, currently under the directorship of Susan Tissot. I had the privilege and fun of serving as curator of education in that museum for 22 years.

Karen Savage of the City of Vancouver's information services supplied photos of downtown's renaissance, when everybody else had gone digital. Linda Lutes of the *Vancouver Columbian* made photos appear as if by magic. Thanks to Kim Hash and the folks from the Historic Reserve Trust who found wonderful photos and suggested new ones as well.

INTRODUCTION

Vancouver, Washington, sprawls along the Columbia River for over 10 miles, and across the river lies Portland, Oregon, rather like a younger brother grown taller and heavier. The river shapes both cities. Indeed, without it, neither city would exist.

For hundreds of years, thousands of Chinooks dwelt in villages along the river. The climate was mild; the river provided abundant food. Wild plants and berries added to their daily fare.

They were the ultimate traders. Wealth brought prestige, and the richest became the chiefs, rather like our own society today. They, however, did not believe that a good war chief made a good chief in peacetime. When they had gathered enough goods, they would have a party and give it all away. That was the famous potlatch.

The salmon was an important part not only of their diet, but of their world. They believed that the salmon were a race of people from the sea who could change their form. They observed that the migrating salmon's bodies would change as their color turned to red. They believed that these people came up the river each year to test the Chinook.

The first salmon was treated with reverence, carried to the village for all to share. The fish was cut lengthwise, never across, and consumed with prayer and ceremony. Anything uneaten was returned to the river and laid in the water headed toward the sea. The salmon would then tell his people that he had been treated with respect and they would return the following year. If he had not been so treated, the salmon would not return.

Today the Propstra clock tower in Esther Short Park celebrates this story with sculptures of salmon and a glockenspiel. Between the ancient legend and today's park lie the stories in this book.

Two decades before the Oregon Trail, Fort Vancouver was an outpost of European settlement. It drew traders and tradesmen of many races, nationalities, and languages. The Hudson's Bay Company had no interest in settling. They were here to do business, and their relationship with the Chinooks was a natural one. Both groups were interested in making a profit.

As the Oregon Trail began in the middle of the 19th century, the fort became a destination for weary immigrants. Here they could rest and replenish their stores. As the British believed that the Columbia River was a natural boundary between the interests of the United States and that of England, they encouraged the settlers to head south, into the Willamette Valley.

But some stayed, setting out land claims along the river and in the fertile plains to the north. There were disagreements between the Yanks and the Brits, of course, but in the main it was a

business relationship. In 1846 the treaty was signed making us American. It was time for the Army to arrive, but they were involved in the unpleasantness known as the Mexican war at the time, so it took them awhile to arrive.

With the introduction of the Army, people felt secure enough to settle and continue building the town. Downtown was settled by folks willing to take a chance. Land titles were in doubt for over 50 years due to overlapping land claims.

Transportation was the big issue that kept Vancouver from growing in the early years. The river that gave us life became a barrier. It silted up and cut off the wharf from the main channel. Portland began to grow, but Vancouver was isolated. The railroad came in south of the river, and it would not be until the 20th century that the railroad spanned the river. Not until World War I was the river dredged to Vancouver. Ferryboats operated until 1917 when the Interstate Bridge was built.

Today, Vancouver finds itself in an ideal location for growth. We stand athwart two major highways, along a mighty river. A major airport lies just across the bridge. The growth has been nothing short of phenomenal. The little settlement of the frontier has grown to a city of over 150,000 souls, and the end is not yet in sight.

One

THE EARLY EXPLORERS

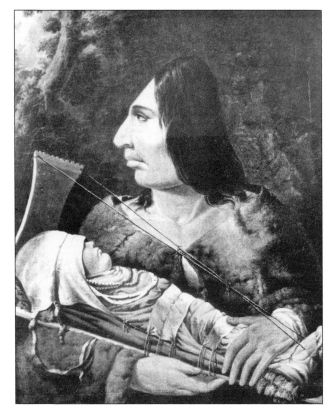

Chinook infants were bound onto boards and then another board was tied over the forehead for several months. The result would be a flattening and broadening of the head, making a straight line from the nose to the crown. This was considered a mark of beauty and status. (Painting by Paul Kane.)

The Chinook watched a curious event in November 1792: a longboat rowed by sweating British sailors making its way up the river. Capt. William Broughton had been sent by Capt. George Vancouver to explore and name the land for king and country.

Apparently an American, Robert Gray, had just made his way into the river and named it for his ship, the Columbia Rediviva, giving the United States a claim on the land. When Captain Vancouver heard of Gray's exploit, he immediately headed for the river in a sort of "cover your aft" move. His ship, the Discovery, was too large to pass over the bar. Several times they tried, inching forward, taking readings, falling back. At last he sent William Broughton in the Chatham. Distrusting the braided river, Broughton left the Chatham and proceeded in the longboat.

Broughton rowed to a place about seven miles above the present-day city, named it Point Vancouver, raised the British flag, and claimed all that he could see in the name of Good King George III. He then had a tot of rum and headed back for the Pacific. He had named the bend in the river "Bellevue Point."

As he reached the site of today's Interstate Bridge, a band of Chinooks led by a one-eyed chief rowed out, smiling, waving, and laughing, to accompany the party downriver. On his map Broughton termed that stretch of the river "Friendly Reach."

Everything settled back to normal for the Chinooks with the departure of the explorers—until November 1805, when they spied another group of strange looking people arriving on their shores. Lewis and Clark and the Corps of Discovery must have been a pretty bedraggled group by then, having traveled for over 18 months. The presence of Native Americans Sacagawea and Pompey with the corps assured the Chinooks that this was no war party, although York, Clark's black slave, elicited much curiosity.

When Lewis and Clark saw Mount Hood, they knew where they were because they carried the maps that Captain Broughton had made. They noticed that the Chinook were wearing British sailors' clothes, and that English words had crept into their vocabulary. The signs of smallpox were also visible on their faces, evidence of European contact. Indeed, the mouth of the Columbia had become a regular port of call for ships from America and Europe. Lewis and Clark fully expected to find a ship there and already carried a letter of credit from President Jefferson guaranteeing their passage home.

But no ship arrived that winter, and they made the decision to return home the same way they had come.

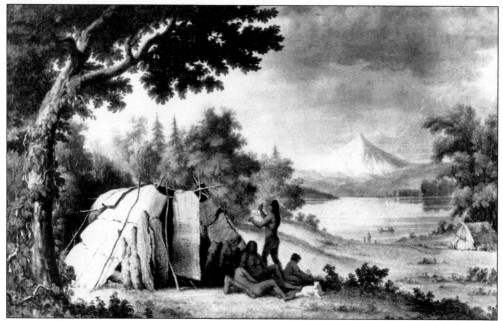

A Chinook hunting lodge is shown here on the shore of the Columbia River near Vancouver. Chinook villages were built of cedar planks, and their long houses sometimes reached over 100 feet in length. Thousands of Chinooks lived along the river near present-day Vancouver.

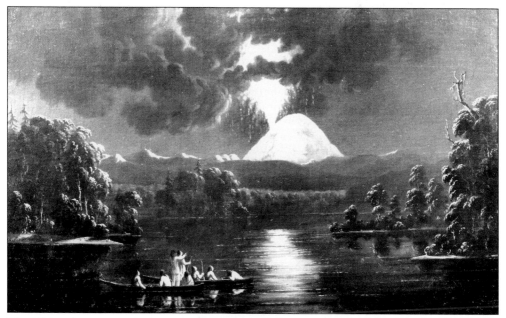

The Chinook were expert canoe makers, adorning them with elaborate carvings. The canoes, like these shown in the Columbia River, were sought after trade items. Mount St. Helens (in the background) erupted on December 5, 1842 and was active for several months.

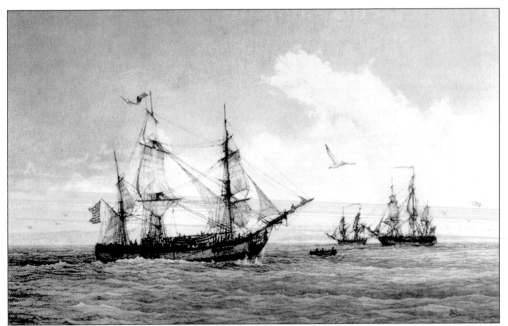

The *Lady Washington* is a replica of the *Columbia Rediviva*, the ship in which American Robert Gray entered the Columbia River in 1792. When Gray named the river for his ship, British sea captain George Vancouver knew that he had to send someone to explore the river to ensure the British claim to the Northwest. Capt. William Broughton got the job.

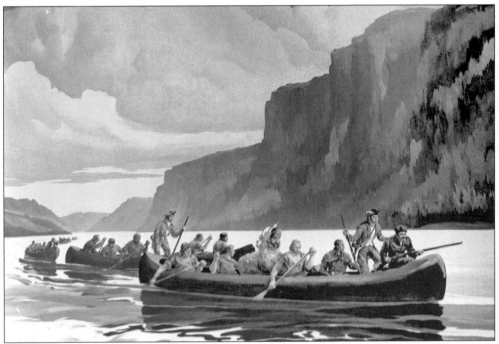

Lewis and Clark are shown here on the Columbia. When the explorers sighted Mount Hood, they knew they were in the part of the river that Captain Broughton had mapped and that they were very close to the Pacific Ocean.

On March 30, 1805, as the Corps of Discovery returned from Fort Clatsop, Merriwether Lewis wrote, "This valley would be competent to the maintenance of 40 or 50 thousand if properly cultivated and is the only desirable situation for a settlement which I have seen on the West side of the Rocky Mountains." Obviously Vancouver outdid this prediction.

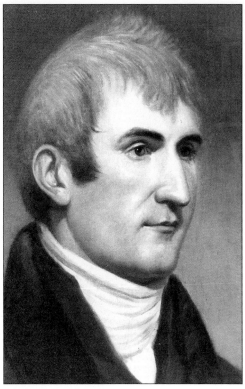

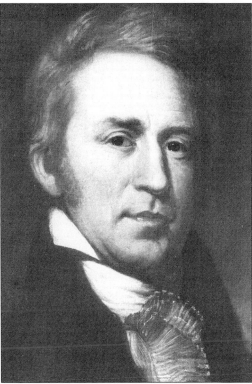

Clark County was named for William Clark who, on the downriver trip in March 1805, kept the journals while Lewis was unwell. The county's name was misspelled as Clarke County until 1925, when, on Christmas Day of that year, Gov. Roland H. Hartley decreed the proper spelling.

Dr. John McLoughlin was known as the "Father of Oregon." He was also called "the White Headed Eagle" by the Chinooks and was noted for his fair dealings with everyone. In a letter to the provisional government in Champoeg, McLoughlin agreed to pay taxes on the goods that he sold the American settlers, "to maintain the peace of the community and prevent the commission of crime, a protection which all parties in the County feel they particularly stand in need of."

Two

THE HUDSON'S BAY AND THE BEGINNING

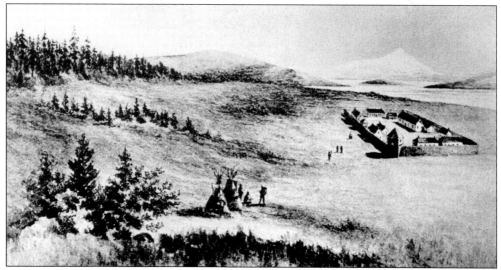

The Hudson's Bay Company fort is shown here in 1833. North of the fort was dense forest while upriver was a treeless plain on which the company built a lumber and grist mill. The road from the fort to the plain was called "the road to the mill plain." The second plain was near Burnt Bridge Creek, and the third is just east of the Westfield mall. The largest was the fourth plain from the river. The road to the fourth plain ran through the second and third plains.

The Hudson's Bay Company was chartered in 1670 in response to the growing demand for North American beaver pelts. The demand for pelts, from which felt hats were made, had led to the extinction of beavers in England and Europe.

John Jacob Astor began fur trading on the Columbia River in 1811 at Astoria. During the War of 1812, the British captured the fort of the Northwest Fur Company. Dr. John McLoughlin, who was working for that company when a skirmish broke out with the Hudson's Bay Company, helped negotiate a merger between the two companies in 1819. By then the Treaty of Joint Occupancy between the United States and England had been signed, giving both nations the right to settle the country.

The new company decided to transfer its operations to the confluence of the Columbia and Willamette Rivers, a business decision rather like locating at a freeway interchange today. A fort was built on the bluff at Bellevue Point but proved too far from the river, making it difficult to bring goods up the hill. Consequently the fort was rebuilt closer to the river.

George Simpson, the governor of the company, broke a bottle of rum across the flagpole, and said," In behalf of the Honourable Hudson's Bay company, I hereby name this establishment Fort Vancouver, God save King George IV." He later said, "The object of naming it after that distinguished navigator is to identify our soil and trade with his discovery of the river and coast on behalf of Great Britain." Apparently he had forgotten about Robert Gray.

Dr. McLoughlin quickly made friends with the local tribes and gained the name "Hyas Tyee" (great chief) and "White Headed Eagle." He was the absolute ruler of the fort, conducting its business and governing the country. Inside the fort were living quarters for the gentlemen of the company, as well as a trade store, fur storage, a doctor's office, a jail, various trades' buildings, and a Hawaiian church.

Outside the walls a village sprang up. Here lived Iroquois, French Canadians, and Hawaiians. In fact, Vancouver had the largest settlement of Hawaiians outside of the islands. In time almost half of the work force would be Hawaiian.

By the mid-1840s the beaver were almost gone, so the fort turned to agriculture and trading. The farms grew enough to sustain the residents as well as to export some goods. From Fort Vancouver, the Hudson's Bay Company controlled 34 other forts and posts from British Columbia to Hawaii.

The great trek west had begun, and in spite of instructions to the contrary, the company sold tools, food, and ammunition to the new American settlers. However, much of the trade was on credit, and by 1844 McLoughlin was owed $31,000.

The United States and Britain were by now saber rattling. "54-40 or fight" and other such slogans were common. In 1846 a treaty was drawn up establishing the boundary between the two countries at the 49th parallel. In a burst of imagination it was called the Treaty of 1846. The Hudson's Bay Company was stranded deep in American territory. Three years later the U.S. Army arrived. The army and the company coexisted until 1860 when company operations were moved to Victoria.

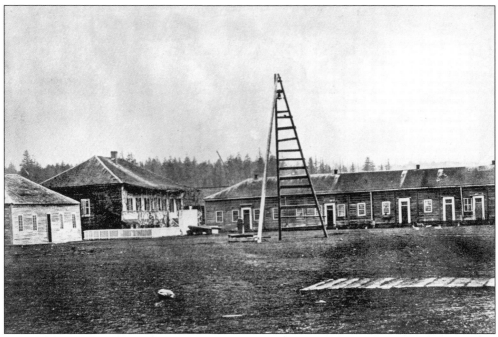

This interior view of the Hudson's Bay Company fort shows the counting house on the left, the chief factor's house in the center, and the gentlemen's quarters on the right. Workers lived outside the fort in the village. The company was the de facto government of the countryside.

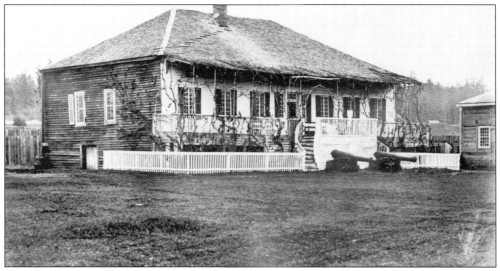

Dr. John McLoughlin ruled as chief factor from this house, which was the scene of entertainments as well. The gentlemen dined with the doctor in the dining room while the ladies dined with Margaret McLoughlin, the factor's wife, in her separate dining room.

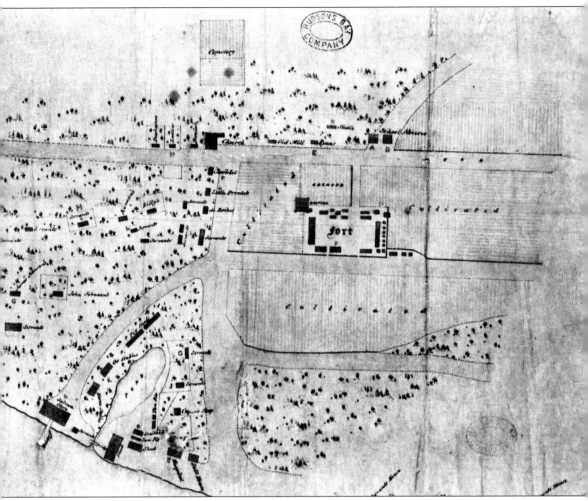

This map of the fort and vicinity was drawn by Richard Covington. Cultivated fields surround the fort while to the west are the small huts of the village. A salmon store is at the end of the dock to the west. The Hudson's Bay Company sold salted salmon to ships. By the time the ships reached Hawaii, those on board wanted no more salted salmon. Fortunately, the Hawaiians loved it and would chop it with vegetables to create a dish called lomi lomi salmon.

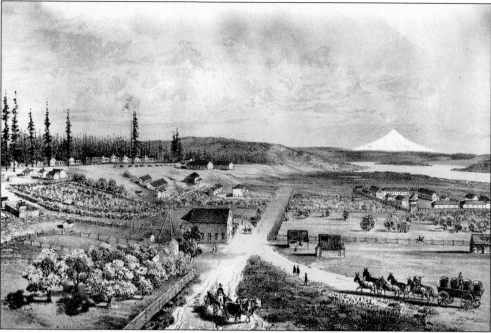

This view of the Hudson's Bay Company after 1849 shows that army structures were appearing on the bluff above the fort. The original St. James Church is depicted across the road, with the cemetery to the rear of the church. The company and the army coexisted from 1849 until 1860.

The ownership of the land on which this original St. James Church stood was contested by the Catholic Church and the U.S. Army for many years. The army fought the case in court using British law, as the church had entered the area under British rule. When the case was settled in the army's favor, a young army officer went to the church to help the priest move. The priest hit him over the head with a painting of the Blessed Virgin. The painting remains in the officer's family.

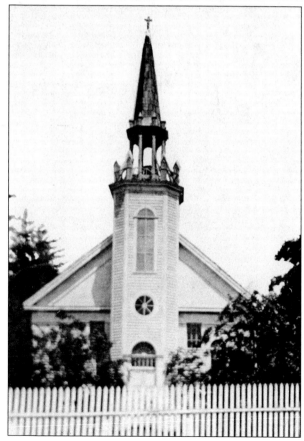

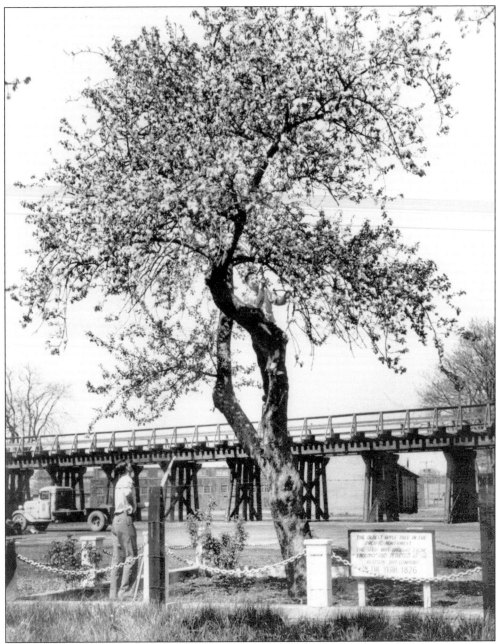

A young British officer found in his jacket pocket the seeds of an apple that had been given to him by his sweetheart in London at a farewell dinner. "Plant these in your wilderness home," she had asked of him. When he showed the seeds to Dr. John McLoughlin, McLoughlin planted them under glass and nursed them until he could plant them outdoors. The trees grew and bore fruit and thus became the first apple trees in Washington state. One of those trees survives today. The old Apple Tree Park lies between Highway 14 and the river, and is reached via a tunnel under the railroad. This photo was taken in the 1940s, before those structures were built.

Three

AN ARMY TOWN

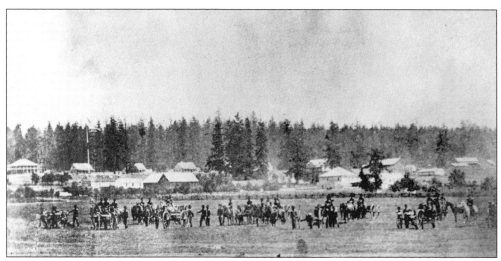

This earliest known photo of Officers' Row shows log cabins standing against a backdrop of dense forest with the Grant House on the left. Soldiers exercise on the parade grounds.

The U.S. Army arrived in Vancouver in May 1849. Houses were needed for the officers, but there was a shortage of workers. The California Gold Rush had begun, and workers rapidly departed. Rufus Ingalls, the quartermaster, offered to pay soldiers $100 to build houses, which proved enough not only to build, but to keep soldiers from deserting for the gold fields.

The houses, built of logs, were finished by September, and the officers termed them "corrals with roofs." One two-story house for the commanding officer stood in the center, while four smaller log cabins were built on either side, placed far enough apart that one could not hear a baby cry from the adjoining home. All are now gone except for the commanding officer's home, which is today known as the Grant House.

In 1856 came the Yakima and Klickitat uprising at the Cascades, and the army moved women and children into the fort for safety. Local men joined volunteer militias and awaited an attack. It never came. In 1867 the old cabins were replaced with more substantial houses, now called Officers' Row. In 1872 the Modoc war began, but there were also hostilities with the Bannocks, the Paiutes, and the Nez Perce. When the treaty with the Nez Perce was revoked, it was feared that they would retaliate. The pursuit of Chief Joseph was on and would continue until he surrendered in 1877. Prisoners from the Nez Perce arrived in the barracks on August 7, 1877. While imprisoned there, an 18-month-old child died; today the occasion is commemorated each year in the Historic Reserve.

Ulysses S. Grant returned to Vancouver in 1879 on a tour to promote the railroads. He also wanted to show his wife, Julia, the house in which he had lived. Soldiers lined the road from the dock to the Grant House with torches, but he turned right and went to Quartermaster Ranch, which had been his true residence. He spent the night at the new O.O. Howard House.

On April 27, 1898 the Spanish-American War began. The 14th Infantry, under the command of Gen.Thomas Anderson, left Vancouver bound for the Philippines, marking the first time American troops left North America.

In 1898 the first contingent of African-American troops arrived; they were the 24th Infantry, Buffalo Soldiers, the heroes of San Juan Hill in Cuba.

On April 9, 1917 World War I began. On February 7, 1918, the Spruce Production Division opened the Spruce Mill, a huge cut-up plant to supply wood for airplanes. Armistice came November 11, 1919 and the Spruce Mill was ordered closed. Sale of its assets began and continued for years. In 1946 the army discovered an office of the Spruce Production Division still operating downtown with a major, his secretary, and his chauffeur tying up loose ends. That office closed immediately.

The 321st Observation Squadron was based at Vancouver Barracks, joining the pilots flying from the polo field. In 1925 the airfield was dedicated in honor of Alexander Pearson, a young army pilot from Vancouver who had died practicing for a speed run.

In the 1930s the Civilian Conservation Corps was headquartered at the barracks under the command of Gen. George C. Marshall, who would leave on the eve of World War II to lead the military. On December 7, 1941, the barracks became a whirlwind of troop activity, and a prisoner of war camp was installed at Pearson Field. The first POWs were Italian soldiers, and German POWs were not far behind.

After the war, the army began surplusing the barracks. When Officers' Row was declared surplus the citizens of Vancouver went to work to save it for the community. In 1986 the deed for "the Row" was given to the city and the rehabilitation of the houses began.

The Museum at Pearson Field was created in 1988. Later a grant from the Murdoch Foundation allowed the restoration of the hangars and provided a home for the museum.

The regular army at the post dwindled, and in July 2000 the garrison flag was furled and marched off the base. The 104th Division of the Army Reserve continues to maintain headquarters there, and the Washington National Guard keeps the military presence.

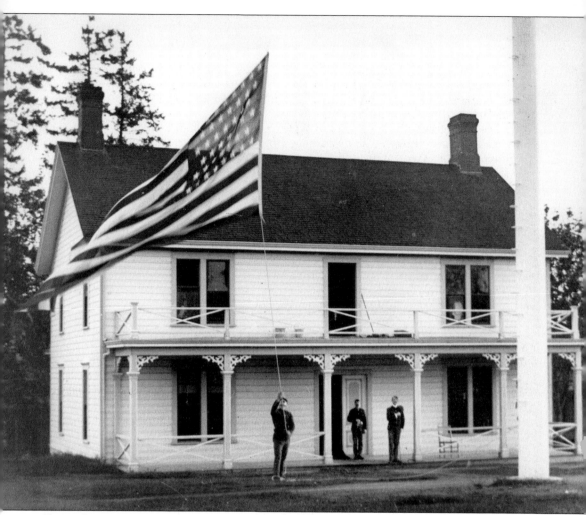

Shown here is Quartermaster Ranch, where Ulysses S. Grant lived with Thomas Brent and Rufus Ingalls. The house was a prefabricated structure that Ingalls had shipped from San Francisco. He wrote to his wife that "it was the grandest house in Oregon." The quartermasters entertained with soirées and sleigh rides.

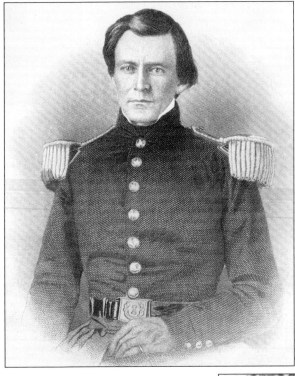

A young Ulysses S. Grant arrived in 1852 as a brevet captain. He was sad and lonely, missing his wife, Julia, and their children. A baby boy had been born after he left Sackett's Harbor.

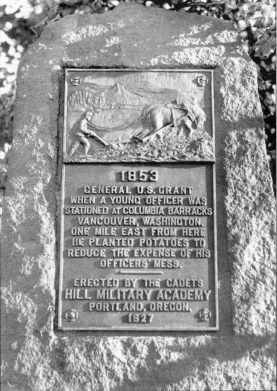

1853
GENERAL U.S. GRANT
WHEN A YOUNG OFFICER WAS
STATIONED AT COLUMBIA BARRACKS
VANCOUVER, WASHINGTON,
ONE MILE EAST FROM HERE
HE PLANTED POTATOES TO
REDUCE THE EXPENSE OF HIS
OFFICERS' MESS.

ERECTED BY THE CADETS
HILL MILITARY ACADEMY
PORTLAND, OREGON,
1927

In an effort to raise money to bring his family here, Grant went into partnership with a neighboring settler, Bill Nye, and Captain Brent to grow potatoes—not to save money as this marker says, but to sell to the army. The Columbia River flooded and wiped out his crop. This marker is located at the triangle of Fifth, R, and Davis Streets. The potato field was planted off First and Grand. Grant left in 1853.

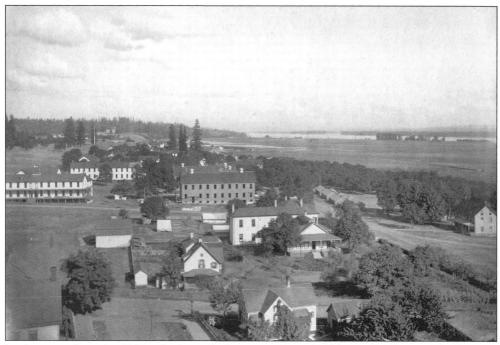

In this view from the 1970s, the barracks have grown, with additional quarters and a hospital now appearing. The flat plain (center left) would one day become Pearson Field.

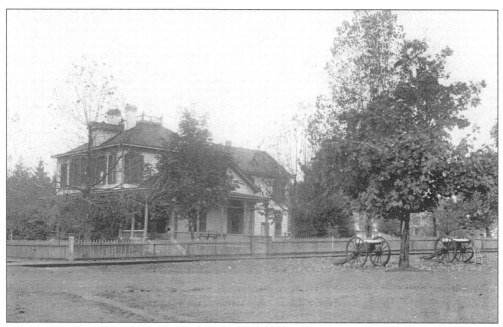

To provide a better residence for the commanding officer, the O.O. Howard House was built in 1879. O.O. Howard was a Civil War general and Medal of Honor recipient who had lost an arm in battle. After the Civil War, Lincoln appointed him head of the Freedman's Bureau. Believing that education was the only answer to the problem of the thousands of freed slaves in the South, Howard became one of the founders of Howard University in Washington, D.C.

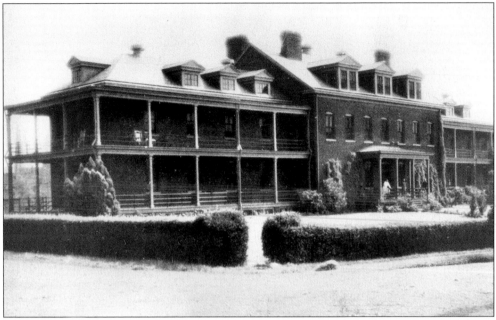

A modern hospital was completed in 1886. Large windows let in light for surgeries, and drains allowed blood to flow into containers below.

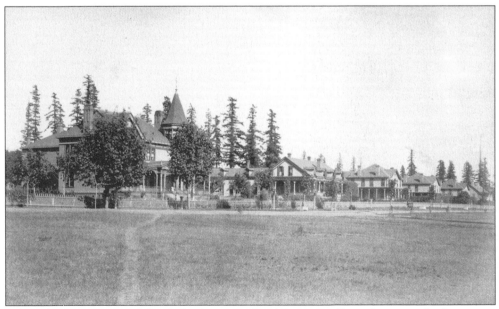

When the Department of the Columbia moved to Vancouver Barracks, a grander house was needed for the commanding general. In response, the Marshall House was built, and Gen. John Gibbons became its first resident.

The log cabins were replaced in the 1870s and 1880s. Here, the Grant House is visible to the right of the new Marshall House.

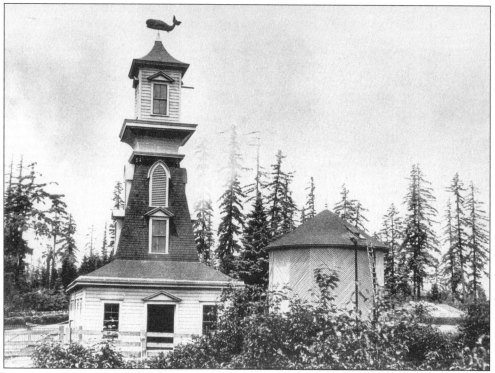

The barracks waterworks included this fanciful structure with the whale weathervane and served as the pump house. The wells still serve the City of Vancouver in Waterworks Park at Fort Vancouver Way and Fourth Plain.

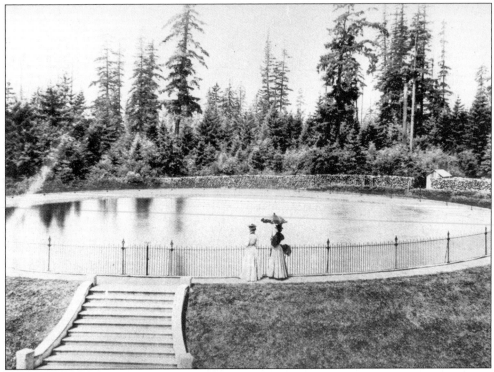

The reservoir at the waterworks was a favorite place for a promenade. It has been replaced in modern times with tanks.

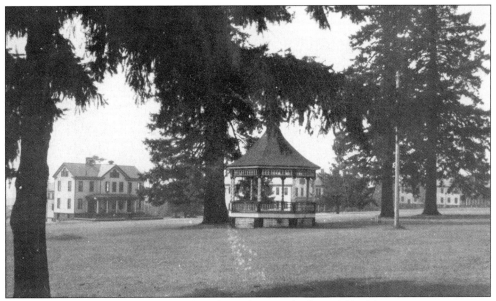

The bandstand on the parade grounds is shown here in the late 1880s. Many attempts to start a city band came to naught because of the presence of the army bands.

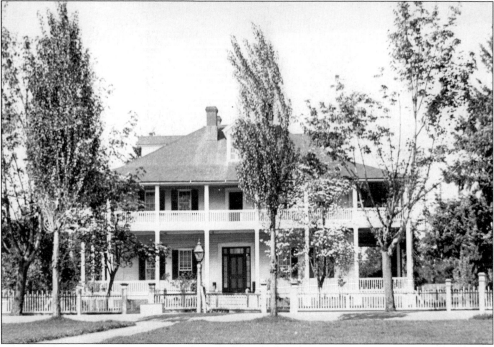

By the 1880s the Grant House was serving as an officers' club instead of a residence. It remained an officers' club for many years, changing to bachelor officers' quarters briefly during World War II. When the building was surplused by the army after the war, it became home to a bridge club until the Soroptimist Club took it over and opened it as a museum on April 26, 1952. The building was converted into a restaurant in the late 1980s.

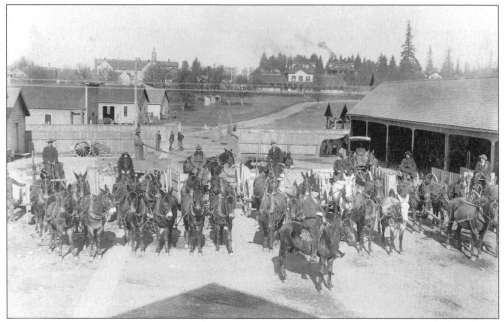

The U.S. Army traveled by mule. Here, civilian teamsters handle the army mules in the mid-1890s. The academy rises in the skyline to the left of center.

This picture and the one on the opposite page were both taken from the flagpole on the parade grounds and show Officers' Row in the late 1880s. The Marshall House, officers' homes, and a caisson with cannon and cannon balls appear in the foreground.

In this view, bachelors' quarters have been built on the eastern edge of the parade grounds. At the left, soldiers stand in formation while others take a break in the shade under the trees.

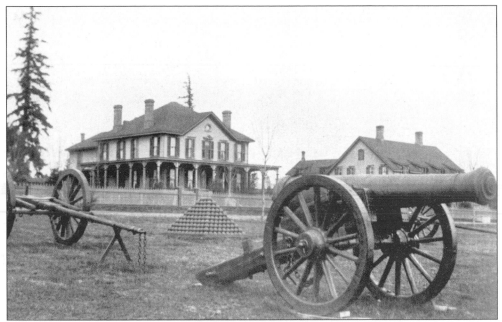

A cannon guards Officers' Row in 1890. While seemingly an idyllic neighborhood, it was first and foremost an army barracks.

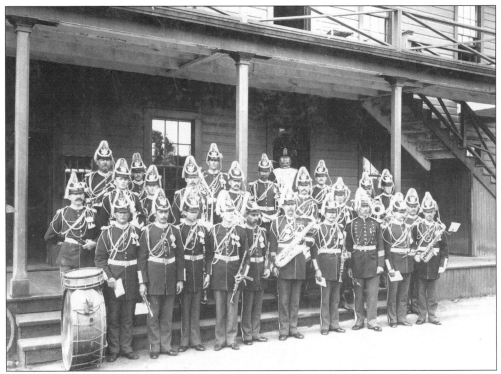

The 14th Infantry Band is shown here in all of its glory in 1898. These uniforms were used only for the most gala occasions.

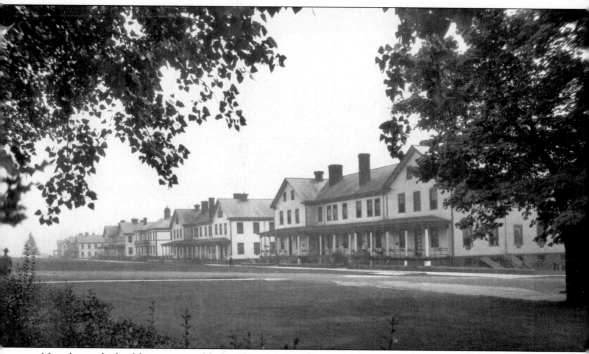

New barracks buildings were added early in the 20th century. Most of these are still standing.

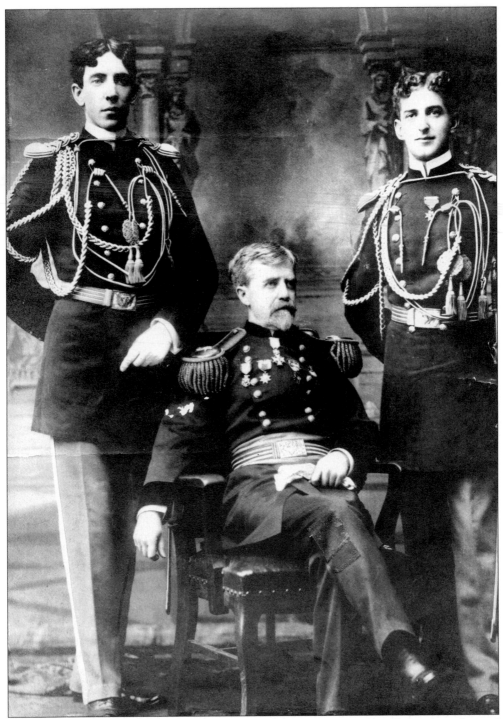

Gen. Thomas Anderson sits between Lt. Robert Allen (later major general), on the right, and his son Thomas Anderson Jr. General Anderson was the longest serving commander of the barracks. He led troops from Vancouver Barracks to the Philippines during the Spanish-American War. His son, as colonel, also commanded the barracks.

Military police lend a certain weight to this view of the guard house, which seems to be lost on the prisoner in the window. Most detentions were for alcohol-related offenses.

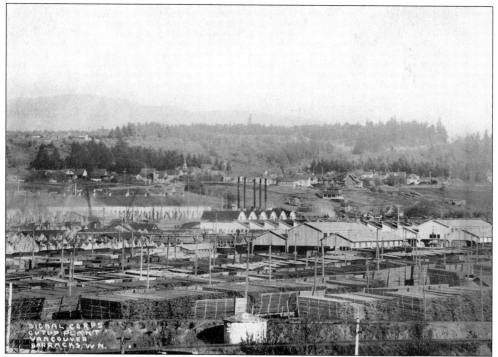

The need for spruce wood to build airplanes led to the formation of the Spruce Production Division. This, the largest cut-up plant in the world, stood on the site today occupied by Fort Vancouver.

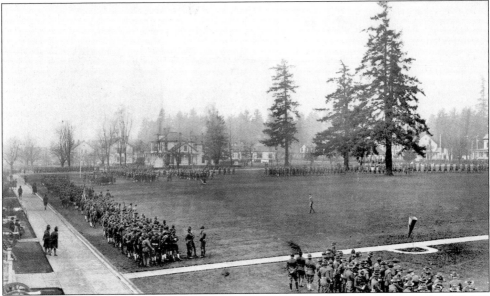

Men of the Spruce Production Division assemble for review. There were upwards of 30,000 men assigned to the division. Spruce was cut throughout the Northwest and brought here for processing.

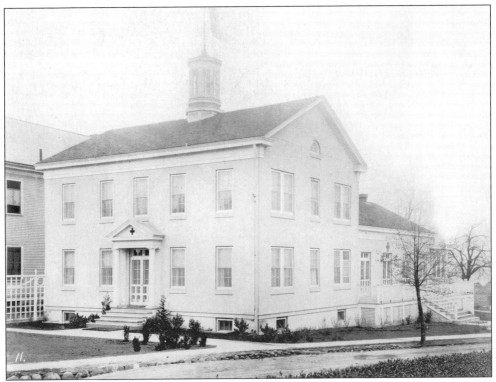

The Red Cross building was constructed in 1919 for the use of convalescing soldiers. Located across the road from the old army hospital, it has since been rehabilitated and is now owned by the city.

Gen. George Catlin Marshall lived on Officers' Row during the 1930s, and he commanded the Civilian Conservation Corps until the outbreak of World War II. His was the mind behind the European campaign of that war. He became secretary of state under President Truman and formulated the Marshall Plan for the rebuilding of Europe, for which he received the Nobel Peace Prize, making him the only career soldier ever to achieve that honor.

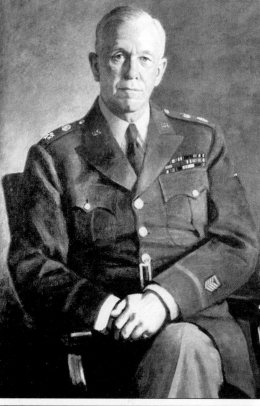

The interior of a barracks is shown in this photo from the early 1900s. A rack of rifles dominates the scene.

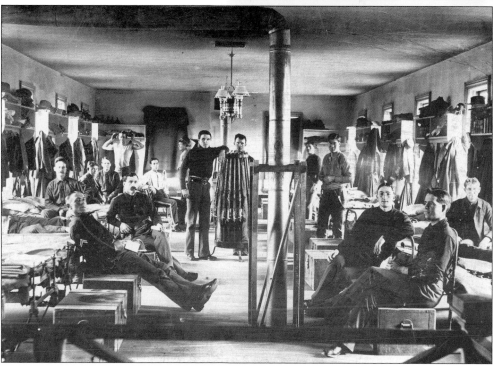

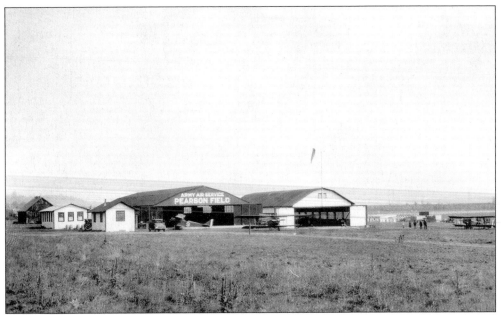

Pearson Army Air Field was named for Lt. Alexander Pearson, a young pilot killed in a speed practice in 1924. Pearson had been a member of the first "flying circus" on the Pacific Coast.

The dedication of Pearson Field took place on September 16, 1925. During the festivities, a pilot threw a dummy out of his plane, causing screaming and fainting among the horrified spectators. In this photo, people are seen running to assist the "victim."

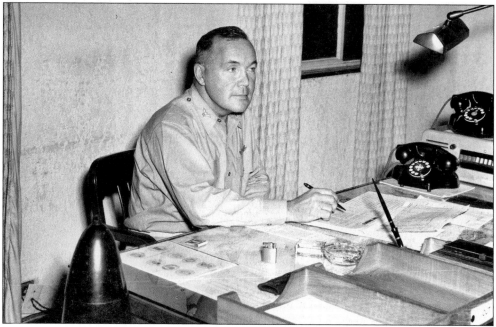

Carlton Bond was the dashing commander of the 312 Observation Squadron based at Pearson. His statue stands in from of the Murdock Air Museum at Pearson.

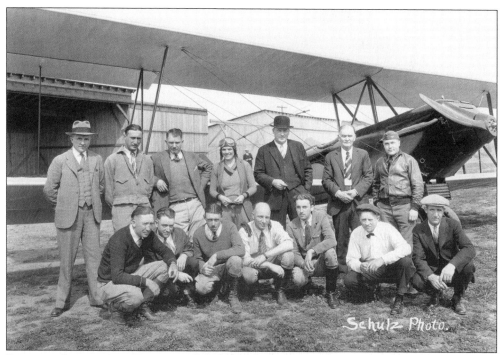

Pioneers of aviation at Pearson included, from left to right, (front row) Burt Justin, Charles Mears, Fred Sauers, Art Whitaker, Sid Monastes, unidentified, and Fred Rafferty; (back row) Henry Rasmussen, Ed Klysner, Les Boyd, Edith Folts, Maj. Gilbert Eckerson, "Dad" Bacon, and Lt. Carlton Bond.

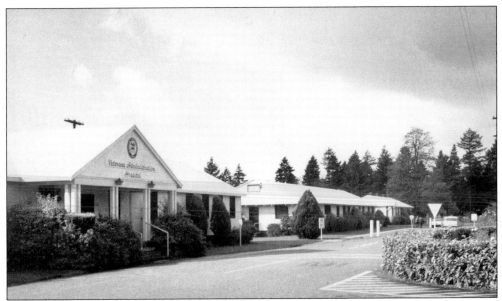

Barnes Hospital replaced the old army hospital in 1941. Soldiers were cared for here until after the war, when it was turned over to the Veterans' Administration. That organization still cares for veterans on the site.

Fort Lewis grew past Vancouver Barracks and became the headquarters, shown here during the 1960s. The Army Reserve and the National Guard are still based here.

Four

THE TOWN BEGINS

The Oregon Trail movement began in 1843 when thousands of Americans headed west. Some wagon trains contained hundreds of wagons pulled by oxen, carrying families' goods and hopes westward. The trail continued for many years. This group of new arrivals was photographed near where the railroad depot now stands.

Sometime before 1845, American Henry Williamson crossed the Columbia River and laid out a claim west of the Hudson's Bay Company. He mapped out a little town, called Vancouver City, registered his claim at the U.S. courthouse in Oregon City, and went off to California, leaving HBC folks in charge. David Gardner wound up as caretaker. Meanwhile, Amos and Esther Short and their ten children had built a cabin on the land. The company tried its best to get rid of the Shorts by burning the cabin and setting them adrift on the river, all to no avail. Time and again the Shorts returned. Tension mounted. Gardner, along with two Hawaiians, met up with Amos Short. An argument ensued, and Amos shot and killed Gardner and one of the Hawaiians. The Americans tried Amos for the killing, but he was found not guilty. Armed with that courtroom experience, he became a judge. One of his duties was to decide land titles—and he decided that he owned the disputed land.

Amos started a business selling produce to San Francisco. On a return trip, his ship went down and all aboard were lost. When Esther went to Oregon City to settle the estate, she found that Amos had never filed their claim. Williamson's claim was intact, however, and the Catholic Church was claiming part of it, as was the army. Esther Short filed her papers and returned to begin selling part of it. After a piece resold, Vancouver City went to court.

When Esther died she left three things in her will: a large piece of land to be a public plaza, now Esther Short Park; the waterfront portion of her land was willed to be a public wharf; and she cut off nine of her ten children. Vancouver City would be in court for 50 years before all of the land titles were settled.

Washington Territory was established on March 2, 1853. The first governor, Isaac Stevens, proceeded to Olympia and began to form a government. In 1860 Vancouver was named the capital of the territory. Residents were excited. Local legislators met in a hotel downtown and waited for the rest of the representatives to show up. None did. An attorney, William Potter, filed suit to bring the capital and the state library to Vancouver. On a split vote, the Territorial Supreme Court ruled against Vancouver.

The town slowly grew, huddling along the west boundary of the barracks and along the river. Esther Short gave the right to land a ferry on her land and built a restaurant and hotel next to the landing. Other business opened to serve the soldiers. Henry Weinhard opened a brewery in 1853, and a second would open in 1867.

Mother Joseph arrived with her band of nuns in 1856. A tall, angular woman possessed of boundless energy, she would transform the city. She opened the first hospital, orphanage, old people's home, and the academy. In her spare time she traveled the Northwest begging for money to build more hospitals and academies. She died in 1902; her last words were, "Remember, sisters, whatever we do, we do for the poor." Her statue stands in the U.S. Capitol, one of only two women so honored.

Vancouver incorporated as a city on January 23, 1857. Ordinance No. 1, ordering businesses to close "on the Sabbath day," would not be passed until March 1858.

In the 1870s Vancouver began to grow. The city had a newspaper, livery stables, hotels, and the Hidden brickyard, while the land office did a brisk business. In 1872 a two-story building for the city was constructed, the lower floor for a fire house, the upper for a council chamber.

The Witness Tree stood at the foot of Main Street. From this balm of Gilead tree, all of the land boundaries in downtown Vancouver were measured. The tree was undermined by the river, and eventually fell in 1912. Andrew Quarnberg, a local arborist, took dozens of cuttings from the historic tree and planted them all over town. None, however, survived. Today the spot is marked by a bronze marker set in the ground just north of Joe's Crab Shack restaurant on the riverside.

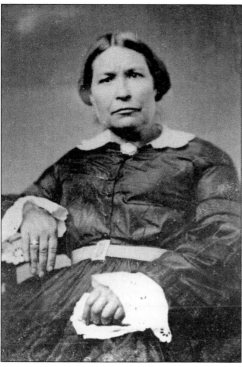

Esther Short migrated from Pennsylvania with her husband, Amos, and their 10 children. They settled on land claimed by Henry Williamson; when Williamson went off to California, the Shorts jumped the claim. As a widow, Esther became a successful businesswoman and, upon her death, left a section of her land to be a public plaza now called Esther Short Park. She left the waterfront part of her claim to be a public wharf, now the Port of Vancouver.

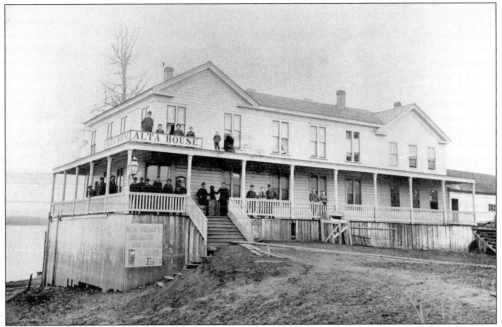

Esther Short gave permission for a ferry boat to land on property she owned. She then opened a restaurant and hotel next to the landing called the Alta House. Since it was the only stopping place for miles, the venture was very successful.

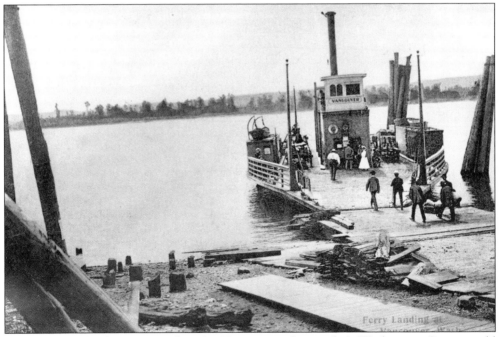

The ferry boat landing next to the Alta House was where today's Washington Street would meet the river, just west of the Interstate Bridge. Washington Street became the main highway.

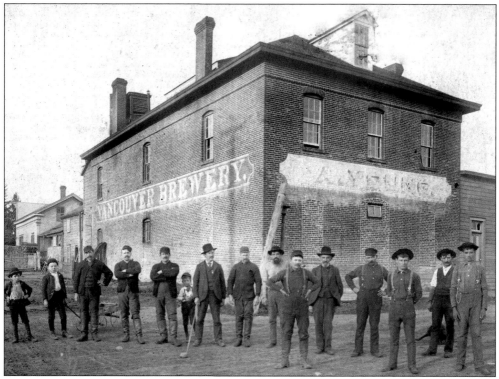

Henry Weinhart's Vancouver Brewery opened in 1853. Good water from wells under the city attracted breweries to the area for the next 130 years.

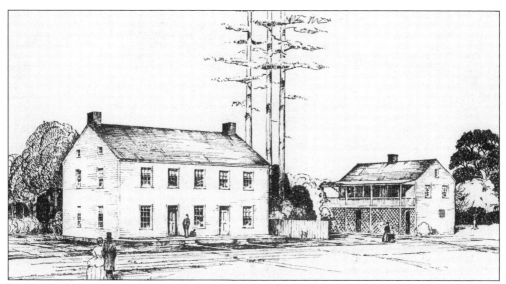

The first Clark County Court House and Jail were located on Eighth Street at West Reserve. They stood from October 1855 until October 1883.

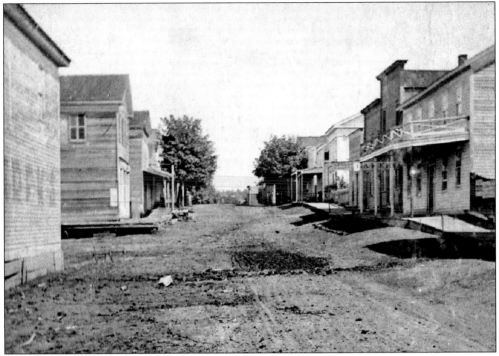

This view shows Main Street in downtown Vancouver in the 1870s. With its dirt roads and wooden sidewalks, it looks like the rough army town that it was. The town grew along the western boundary of the barracks and the waterfront.

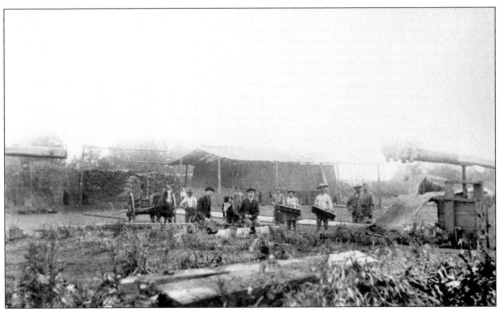

The Hidden brickyard was founded in 1871. One of the company's first contracts was from Mother Joseph to make bricks for the academy. Local lore says that she talked Mr. Hidden into making bricks for the first time. The Hidden Company is still in business, and brick structures still dominate the downtown.

Born Esther Pariseau in Quebec, Mother Joseph was trained by her father as a craftsman. When he took her to the Convent of the Sisters of Providence, he said, "I give you my daughter, she will be a mother superior someday." She came to Vancouver in 1865 with a small band of nuns and immediately began serving the needs of the community by opening the Sisters of Providence Lunatic Asylum.

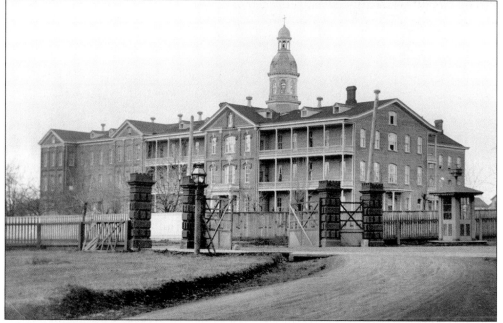

Constructed in 1874, Providence Academy was one of seven academies that Mother Joseph built across the Northwest. One afternoon Mother Joseph, inspecting the work, did not like the way the bricks had been laid. She tore the wall down and made the bricklayers rebuild it the next day. This view was taken from inside Vancouver Barracks looking across Evergreen.

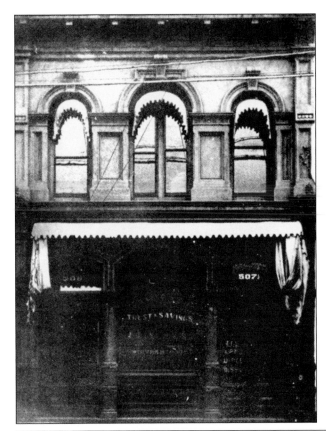

The Vancouver Trust and Savings Bank was founded in 1883 at Fifth and Main Streets. The building was later handsomely faced with terracotta tile, and is now listed on the National Register of Historic Places. A glassblower's studio currently occupies in the building.

Wolf Building stood on Main Street between Fifth and Sixth Streets in 1883. The wolf heads that decorated the front of the building were removed some time after seismic regulations were passed in the 1970s, lest they fall off. The building went through extensive "modernization" and eventually was torn down.

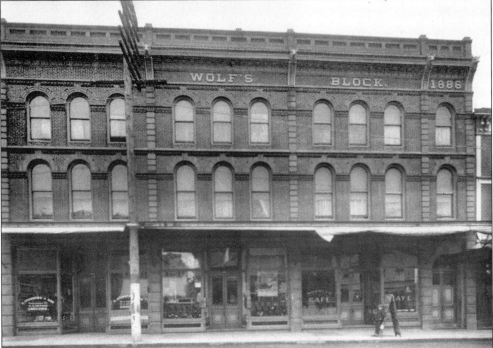

Five

THE 1880S AND 1890S

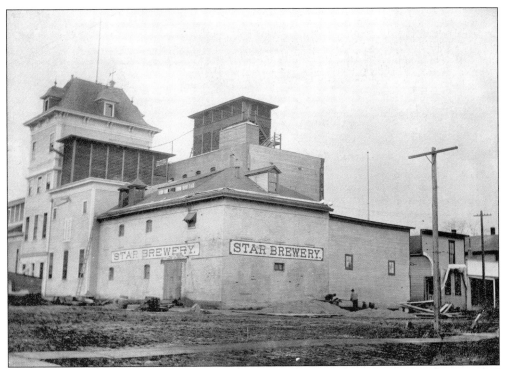

L. and J.T. Gerlinger took over the Star Brewery in 1894 and modernized it for increased production. This picture shows the brewery in 1894, after the modernization took place. The buildings would dominate the downtown skyline for over a century. When Vancouver voted local option prohibition in 1915, the brewery was forced into bankruptcy. It would not reopen until the repeal of the Volstead Act.

The 1880s began with plans for grand buildings. Vancouver was growing, slowly but surely. The grand new courthouse, made of brick and in the Victorian style, was built in 1882. The next year the First National Bank, the first bank in town, opened its doors. The charming little building still stands at Sixth and Main and is home to a glassblowing studio.

In 1884 St. James Catholic Church celebrated its first mass. Its steeple dominated the skyline of Vancouver for many years.

The 1880s were a time of rapid railroad expansion, and Vancouver wanted in. The railroad had come to Portland, indeed, reached to St. Helens on the Oregon side. On the Washington side, it ended at Kalama. The Oregon Steam Navigation Company had boats equipped with rails. They'd pick up the railcars at St. Helens and take them to Kalama. Vancouver was out of the loop and decided to build its own railroad—to Yakima. So was born the Vancouver, Klickitat, & Yakima Railway. The locals called it the Vancouver Klickitat & Yacolt, because that was as far as it got.

One of Vancouver's local heroes was Capt. James W. Troup, a steamboat captain and city councilman who was noted for attempting to navigate a swift route through the Cascades, which at the time were a barrier to trade. Several boats had tried to make it through these notorious rapids, but most came to grief. Captain Troup determined to make the run at low water in the 462-ton steamboat Hassalo. On May 26, 1888, about 100 people from Vancouver journeyed to The Dalles to watch. Troup careened through the six miles of the Cascades in seven minutes.

An early ordinance forbade cows from roaming the streets, but the city quickly received a remonstrance that the ordinance was unfair to poor people. The law was amended to allow each person to graze two cows in the streets. By 1889 the noise had become deafening. One man wrote that between Tenth Street and the river, he had counted 17 cows, of which 10 wore noisy bells.

On February 24, 1890, in the middle of the night, the courthouse burned to the ground. Several prisoners were overcome by smoke before they could be rescued. The rescuer, Timothy O'Neill, was rewarded by being named town constable. Most county records were lost, and it took years to rebuild them.

Even as the courthouse was being rebuilt, the only hanging took place in Vancouver. On July 11, 1890, Edward Gallagher, convicted of murder in Cowlitz County, was hung from a scaffold built in front of the construction site. When asked if he had any last words, Gallagher said, "None of your damned business!" followed by an expletive. The trap was dropped. His tombstone in the old city cemetery reads, "Edward Gallagher, died by legal hanging."

In June 1894 the river began its annual rise and kept on rising. The paper reported houses floating by, then animals. The water reached to Fourth Street on Washington, and to the Providence Academy's garden. Mother Joseph took a statue of St. Joseph and placed it at the edge of the garden and told the river, "This far and no farther!" It stopped there. Where Pearson Field lies today, 300-year-old fir trees died from standing in water. Vancouver's residents, who had only been here for 70 years, didn't know that this was an unusual flood and so they backed away from the river and began locating businesses above Fifth Street, on higher ground.

As the decade drew to an end, war fever was rising. When war against Spain was declared on April 27, 1898, hundreds of young Vancouver men rushed to enlist. At Vancouver Barracks, General Anderson prepared to take his troops to the Philippines. They marched down to the dock and boarded ships for San Francisco. One young soldier wrote that his last view of Vancouver was of the late afternoon sun gleaming off the many church spires in the city.

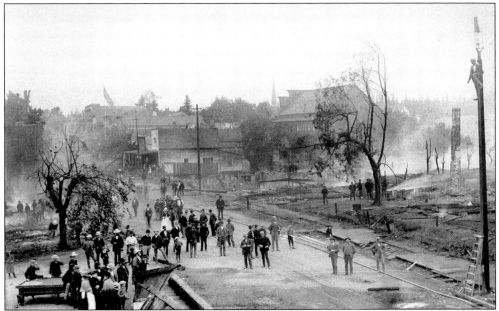

Every city has its big fire. Vancouver's ripped through downtown in 1889, destroying several blocks around Third and Main Streets. Only the brick buildings escaped destruction. In this photo, a man has climbed a pole for a better view of the damage. This event led to the formation of a volunteer fire department.

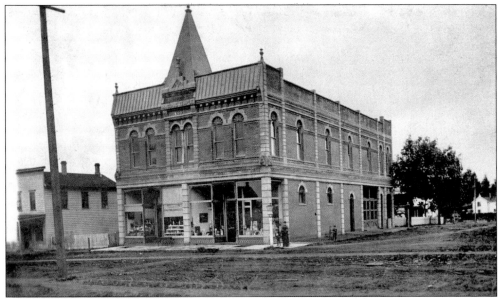

This 1889 photo shows the Masonic Lodge at Eighth and Main Streets. Some lodge brothers complained that the military dominated the lodge, so they formed a second one. The lodges met upstairs and there were retail stores downstairs. In this photo the new fire department is housed at the rear of the building.

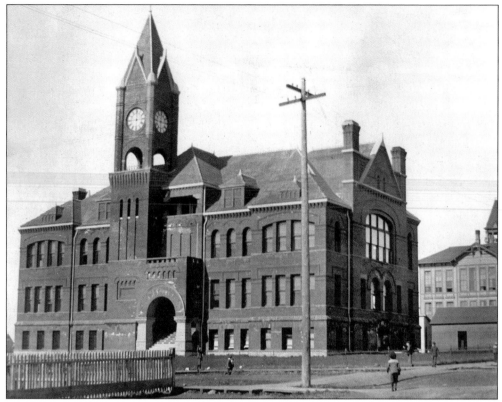

Vancouver residents were very proud of their new "fireproof" courthouse that was finished on February 1, 1892, not quite two years after the fire. The building would be used for almost 50 years.

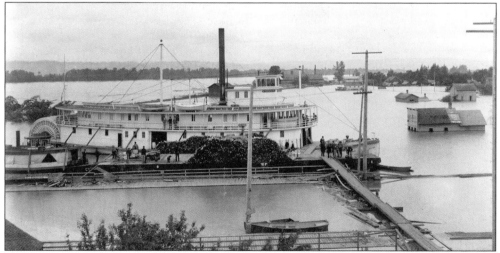

Vancouver had never seen a flood like the great flood of 1894. Here the steamer *Undine* docks at Second and Main Streets. Because the city had only been in existence for about 50 years, residents didn't know how rare a flood like this was; they decided to turn their backs on the river and began to move the business district north of Fifth Street. This slowed the city's growth for many years to come.

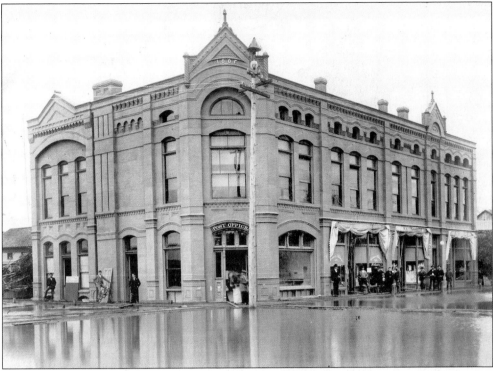

This June 1894 photograph of Washington Street at Fourth Street shows that the high water was a foot deep in the post office. Planks and rubble were laid across the street to allow pedestrians to pass. Note the fallen tree to the left of the building. At what is today's Pearson Field, 300-year-old firs died from standing in the water.

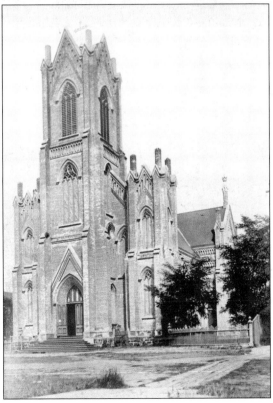

The first mass in St. James Church at Twelfth and Madison was celebrated on August 16, 1885. On that same day final services were held at the old church on the barracks. The altar was carved in Belgium. This Gothic structure is another Vancouver building now listed on the National Register of Historic Places.

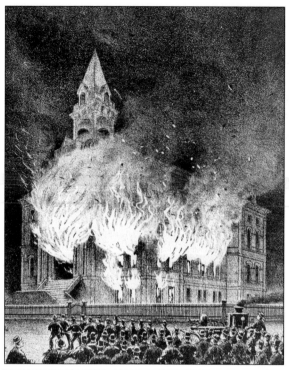

A second great fire struck during the night of February 25, 1890, when the handsome courthouse burned to the ground. The blaze consumed priceless records and land deeds, Esther Short's will among them. No lives were lost, but several prisoners in the jail were overcome by smoke before they could be rescued. A Mr. Sullivan pulled out several of the prisoners and was rewarded by being appointed town constable.

Vancouver's street crew poses on Main Street in the 1890s. None of the streets were paved as yet. Waste liquor from the brewery was used to keep the dust down in the downtown area. The aroma must have been breathtaking in the summertime.

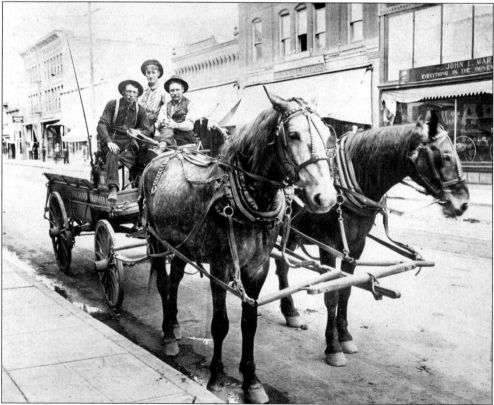

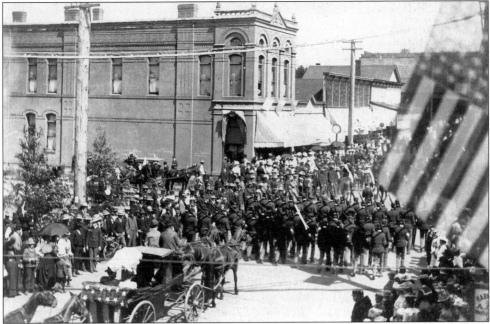

Vancouver has always displayed a spirit of patriotism, perhaps because it was an army town. Independence Day is still celebrated with a huge display, such as this Fourth of July parade at Third and Main Streets in 1892.

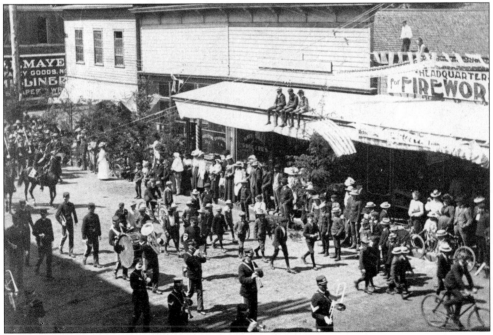

The army band joins the Fourth of July parade in 1895. The city frequently called upon the army for music and occasionally tried to form its own town band. With the army band always on hand, however, those plans usually fizzled. The 104th Division Band still plays for the city on national holidays.

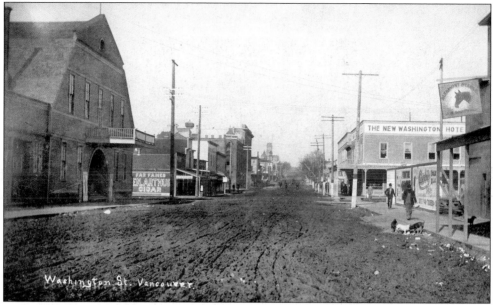

Businesses sprang up along Washington Street to take advantage of proximity to the ferry. This view, looking north from Second Street, shows the Washington Hotel at Third Street. Freeway construction eventually took all of these buildings. The steeple of St. James Church is visible in the distance.

Campbell's Livery Stable was located at 210 West Fourth Street. It was an important location for such a business being just two blocks from the ferry landing and at the corner of Washington Street near the hotels that were beginning to cluster around the landing.

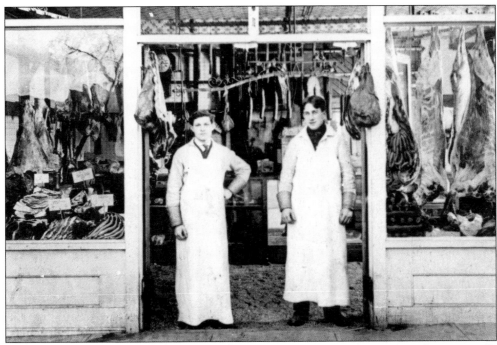

Next door to the Palace Theatre at 601 Main Street was the City Meat Market, originally owned by John Blurock, whose farm was just west of the barracks. His son Charles took the business over in 1897. In the window a beef roast is going for 10¢ a pound, and lard is being sold by the gallon bucket.

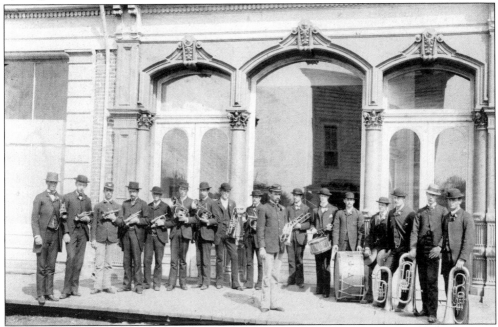

The Vancouver Blue Ribbon Band of 1894 was a mixed civilian and military band. The only identified members are Lewis Eddings (with the cymbals), Will Eddings (with the small drum) and, to his right, John Eddings, who would later serve as mayor of Vancouver.

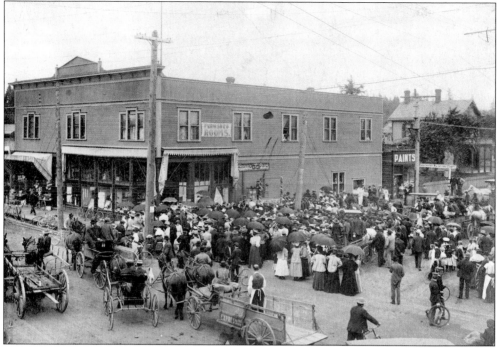

Carter and Carter's Store at Fifth and Main Streets is shown here in the late 1890s. The crowd is gathered to watch a boy portraying Buster Brown, "who lived in a shoe." Behind him, on a chair, is his dog Tige, "who lived there, too."

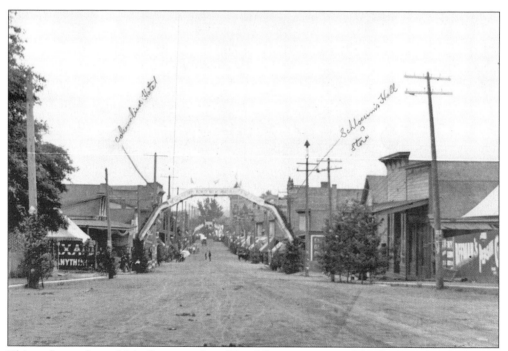

This arch over lower Main Street at about Third Street was erected for the Fourth of July. It is lettered, "We saved the USA in time of War, We should honor it in time of Peace."

Six

THE CENTURY TURNS
1900–1919

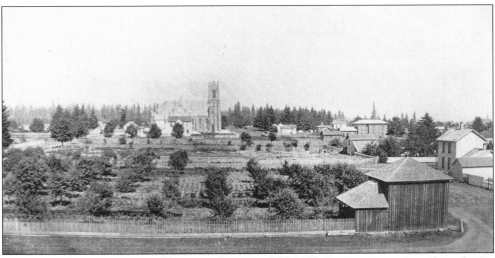

This view looks west from Franklin around 1890 with Twelfth Street running from the right. St. James Church is in the middle distance. Twelfth Street was definitely suburbia then, with cultivated fields around the houses. Vancouver Barracks, in the distance, was still forest.

Change was in the air as Vancouver entered the 20th century. Surely this miraculous new date would bring dizzying changes.

Bicycles were a popular recreation as well as a form of transportation. Automobiles were making their debut—a cause for wonder. On September 10, 1901, the newspaper reported that the second automobile seen on the streets of Vancouver had been spotted that day, "and quite startled the natives as well as the horses." Talk of the railroad reaching Vancouver was afloat.

In 1905 the Lewis and Clark Centennial Exposition opened in Portland. The Vancouver booth was an arch of prunes bordered with apples. Lincoln Beachy flew a dirigible from the fair to the barracks, the city's first sight of aviation.

Work had already begun on the railroad bridge, and the North Bank line was under construction. At the same time Vancouver began laying tracks for a streetcar line that would reach Orchards and Sifton; it opened on September 26, 1908.

The new railroad bridge was completed on June 25, 1908, and Vancouverites were giddy with joy. There was a parade and people carried banners that read "Vancouver, where grain meets rail." Just a couple of weeks later, Silas Christopherson took off from Vancouver Barracks in an airplane with his wife as a passenger. What a decade!

With the opening of the bridge, a building boom ensued. The new Carnegie Library at Sixteenth and Main Streets opened on New Year's Eve, 1909, to show off the fact that it was the first public building with electric lights. Nevertheless, there was grumbling because it was located so far outside of town. Today it is the Clark County Historical Museum. The First Presbyterian Church at Evergreen and Daniels opened in 1912, the new post office on Daniels in 1916. New houses were going up in the Craftsman style.

With the arrival of the railroad bridge, Vancouver realized more than ever that a road bridge was necessary. But when city officials asked Olympia to build a bridge, they were sent to Oregon. Salem officials couldn't see their way clear to build a bridge for Washington, so Vancouverites marched on Portland with banners that read, "We need the bridge and so do you, we've done our part now you come through." They couldn't resist. Multnomah County in Oregon passed a property tax measure for $1,500 while Clark County borrowed $500,000. Together the two counties built the first span of the Interstate Bridge.

The new bridge opened with great bi-state festivities on Valentines Day, 1917. Less than two months later the nation entered World War I. Downtown again surged. Three shipyards opened west of the Interstate Bridge, and 30,000 men came into the barracks to set up the Spruce Production Division.

Vancouver voted local option prohibition in 1914, throwing the brewery into receivership. Customers of the area's orchards had been brandy makers; they were lost as was major customer Germany. Out of work, many turned to illegal stills and brewing. When the Volstead Act enforced the wartime prohibition measures, Vancouver residents were already in the moonshine business.

World War I ended on November 11, 1919. Military contracts to the shipyards ended, and they were gone by 1921.

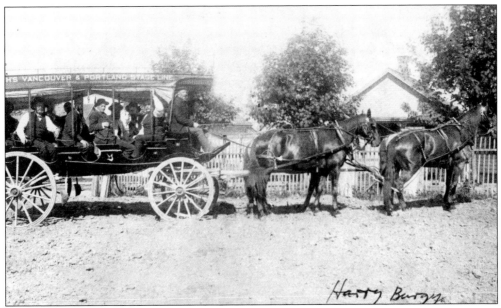

Harry Burgy drives Smith's Portland Vancouver Stage line just before 1900. This rig would meet the ferry and deliver passengers to far-flung communities such as Hazel Dell or Orchards. The corresponding rig on the Oregon side might take you all the way to Oregon City.

This May Day celebration took place in Esther Short Park in 1902. The name of the young girl in the center, portraying the Queen of the May with her attendant train bearer, has unfortunately been lost to history.

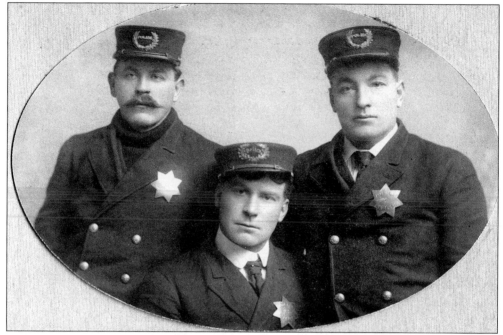

By 1902 Vancouver was big enough to warrant a real police department that included, from left to right, Winfield Gassoway, Harry Burgy, and John Secrist. Until then the city had made do with town constables as well as calling on the sheriff. Both constables and sheriffs were rarely trained law enforcement people; they were good citizens who stepped forward to serve, then went back to their regular lives.

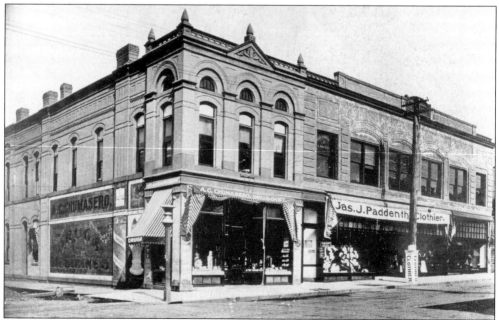

Padden's Men's Store was located in the Schofield Building on Main Street between Sixth and Seventh Streets. Mr. Padden, the owner, became active in politics, and the Padden Expressway was named for him.

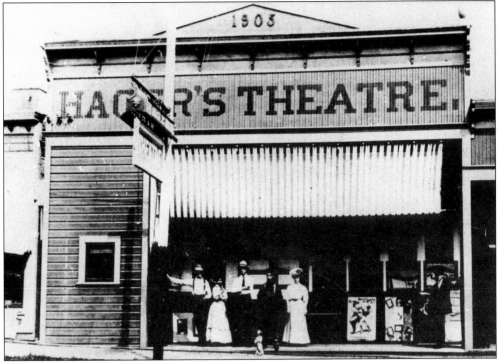

Hager's Theatre opened in 1905 at 705 Washington Street. On November 12, 1908, the theatre showed a moving picture of Vancouver scenes. Filmed by Mr. Hager and his partner, Gallagher, it showed the Vancouver Fire Department responding to a fire and a panoramic picture taken from the streetcar from the ferry to Tenth Street. They reported, "This is the first moving picture that has ever been made of local interest."

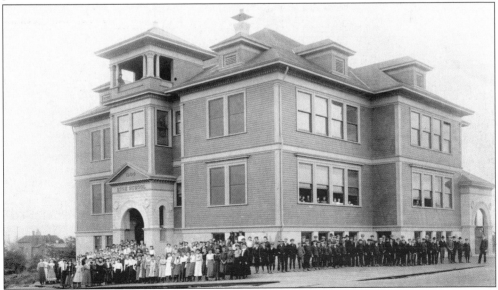

Vancouver had grown enough by 1902 to need a new high school, which was built at Fifteenth and Franklin Streets. Until then, schools had been hit or miss, the school year running until the city ran out of money to pay the teacher. School was often suspended during berry picking time.

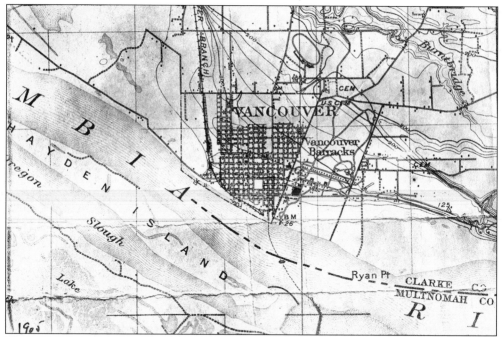

This map of Vancouver in 1905 shows the city limits to the east extending only as far as the military barracks, north only to Eighteenth Street, and west to Markle. The railroad had passed the city by, reaching to St. Helens on the Oregon side and Kalama on the Washington side. Goods were transferred across the river by special steamboats.

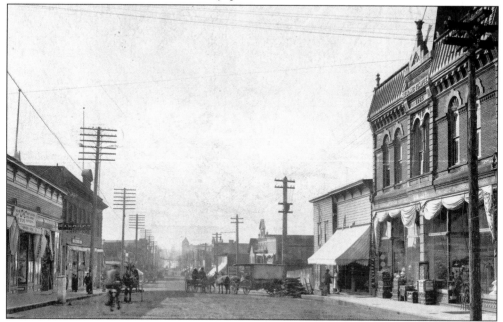

This view, looking south on Main Street in 1905, shows wooden sidewalks and a muddy street. The Witness Tree can be seen at the foot of the street with the Masonic Temple on the right and a secondhand store on the ground floor. The wagon is unloading wallpaper. The C&C dry goods store is on the left.

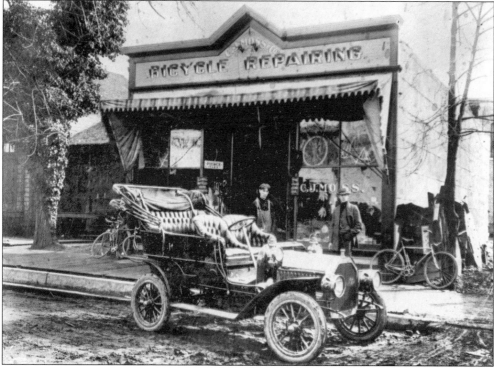

Clyde Moss's bicycle repair was located at 605 Washington Street. Here, Clyde Moss shows off his brand new 1907 Buick. He would soon start selling cars as well as bicycles, an omen of things to come. Moss and his father-in-law, Andrew Quarnberg, kept weather records for the U.S. government for over 75 years at their home on Kauffman Street.

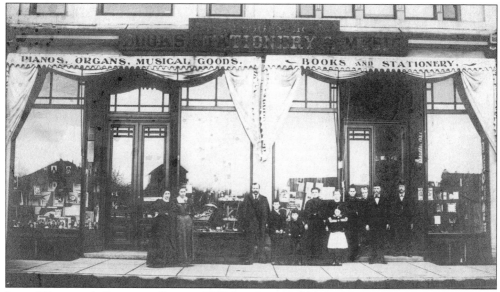

James Waggoner's Stationery Store at 705 Main Street sold musical instruments, lessons, books, and bric-a-brac as well as stationery. Most families had some sort of musical instrument and someone who could play. Mr. Edison's phonograph was on its way, though.

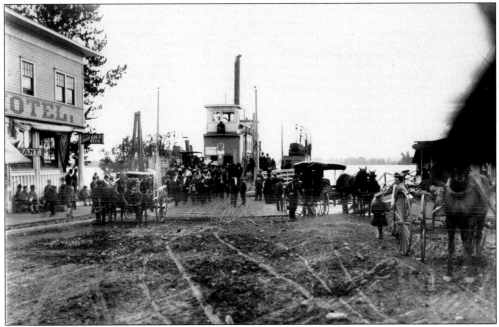

The ferry landing was located at the foot of Washington Street, which today would be just west of the Interstate Bridge. The Ferry Hotel is on the left. Hackney cabs and stage lines wait for interested passengers.

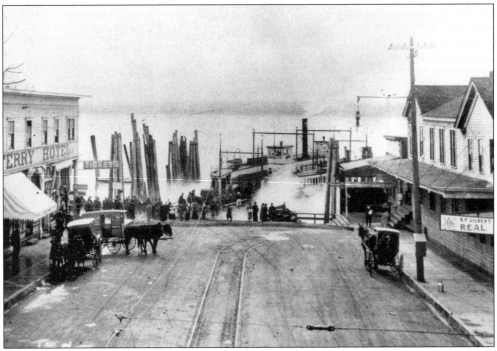

Two years later, street car lines meet the ferry, but the cabs and stages still compete for clients in this 1890s view. Traffic begins to back up on the ferry at about this time. Some people had to wait an hour or more for a place on the boat.

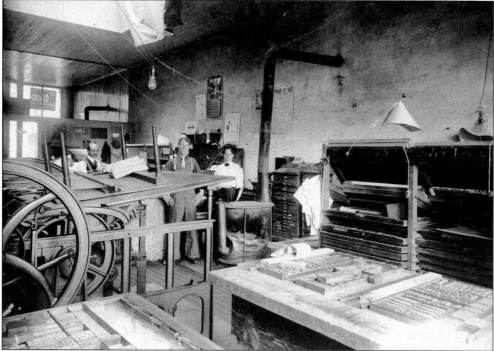

The DuBois Print Shop at 313 Main Street was owned by Lloyd DuBois, editor of the *Independent* newspaper. DuBois railed against the vice in the tenderloin area, which extended from the edge of the barracks to the back of his office. He ran for mayor on a reform ticket, vowing to clean up the saloons and vice dens, and lost miserably.

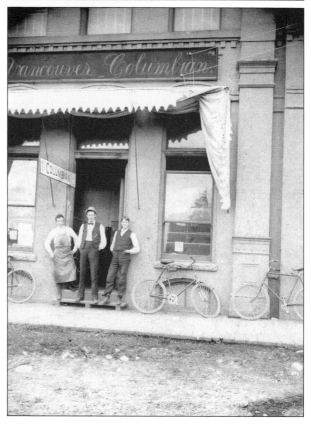

The *Columbian* newspaper office at Fourth and Washington Streets is shown here about 1900. The man in the center is the editor, J.C. Gaither. The *Columbian* would buy out the *Vancouver Independent*'s subscription list in 1910 and become Vancouver's only newspaper.

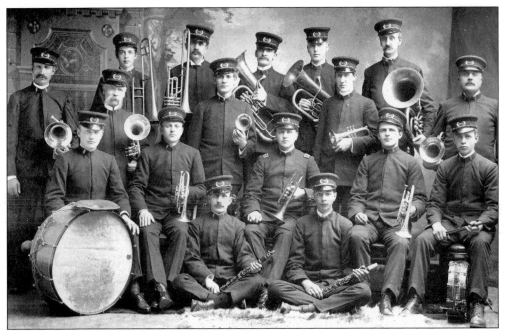

The proud new Vancouver City Band of 1907 was formed "to provide music to the city without the necessity of always calling on the military as has been the case in the past." Ralph Avery was the bandmaster.

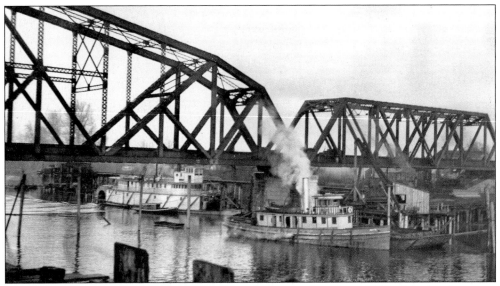

The railroad bridge, designed by Ralph Majeska, opened in June 1908. For the first time Vancouver had a connection to Portland, and the rest of the world was no longer cut off from Vancouver.

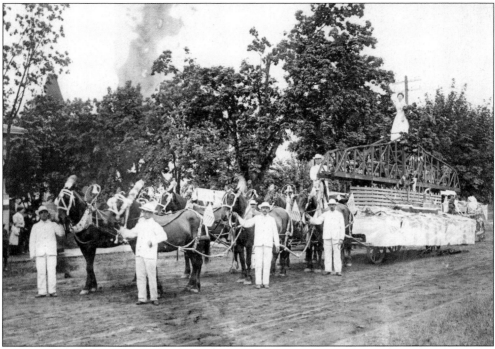

Locals celebrated the new bridge with a grand parade. This float shows a portion of the bridge and the legend, "Vancouver, where grain meets rail." Many wealthy businessmen were sure that the center of town would shift to the west to be near the railroad, and they built grand new homes near the depot. The shift did not happen.

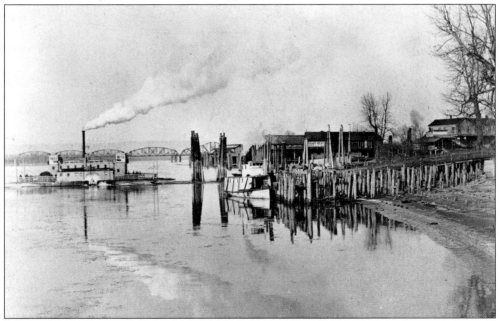

The ferryboat *Vancouver* leaves the landing en route to Portland in 1909, with the new railroad bridge behind it. Vancouverites had not yet noticed that there was no wagon road on the bridge. They were still dependent on the ferry.

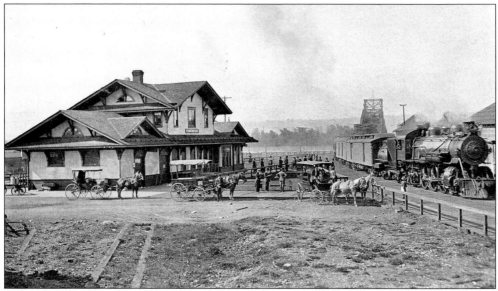

Stage lines and buggies now also wait for passengers at the new railroad depot at the foot of Thirteenth Street. The railroad line ushered in a period of boom for Vancouver.

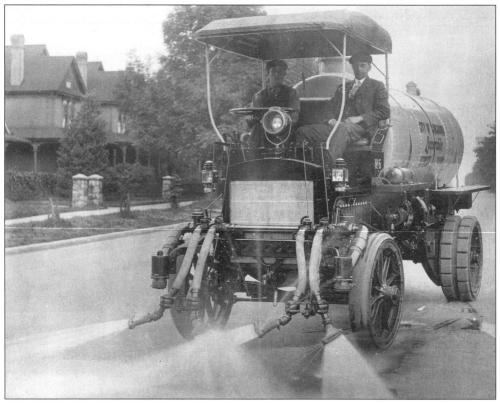

A street flusher is shown in action on Thirteenth Street, watering the street to keep down the dust. The "Locomobile" was steam powered until 1902, then it switched to gasoline. The tires were solid. Folks were obviously very proud of this expensive machine.

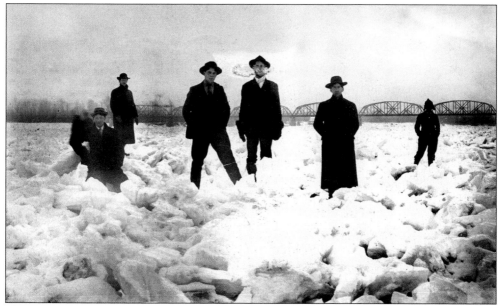

The Columbia River regularly froze over before the dams were built upstream. This 1909 view of people walking out on the river shows the railroad bridge in the background. More daring folks drove their cars out onto the ice.

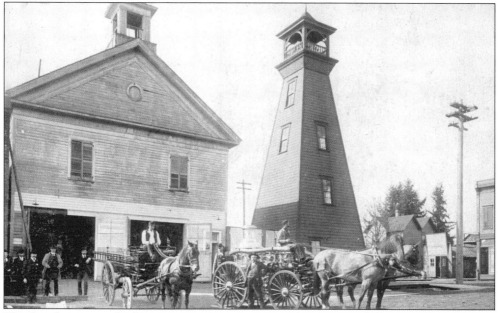

The fire department had grown into its new quarters by 1909, and the city council rented a room in the station to hold meetings. The little building across the street is a carriage and sign-painting business.

Land seekers wait outside the U.S. Land Office located in the Vancouver National Bank at Sixth and Main Streets. One could file for land, which, if it was worked and improved, could become the property of the filer. Streetcar tracks are under construction in front of the bank.

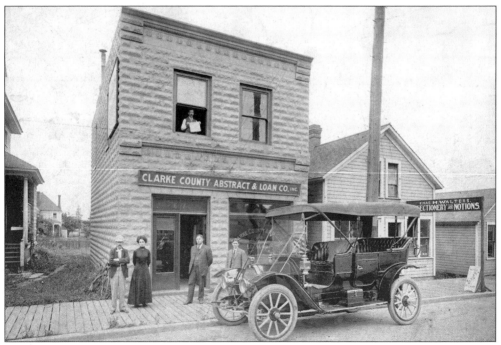

Clarke County Abstract and Loan was located at 607 West Eleventh Street, across the street from the courthouse. Shown, from left to right, are an unidentified person, Alice Tooley, Allison Burnham, and R. Homan. R. Burnham looks out of the second-story window.

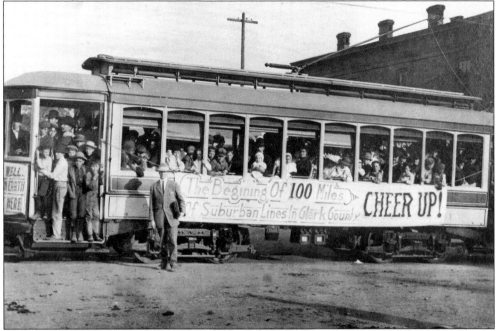

The Orchards Sifton streetcar line opened with great fanfare on September 26, 1908. The route from Vancouver roughly followed today's State Route 500. The line lasted until 1925, carrying not only passengers, but freight from the river to Orchards.

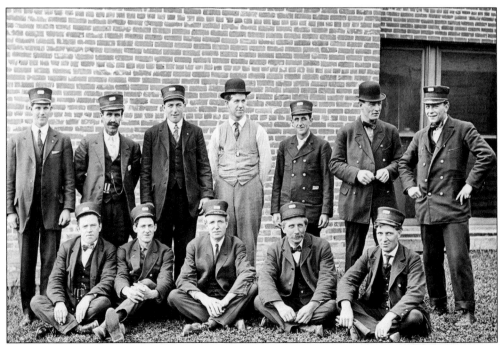

These streetcar motormen, from left to right, are (front row) Jim Callahan, unidentified, Jim Garner, James Ellison, and Fred Fuller; (back row) Roy Carson, Frank Stickney, Roy Adams (manager of the company), Billy Springer, Frank McWilliams, unidentified, and Bill Levine.

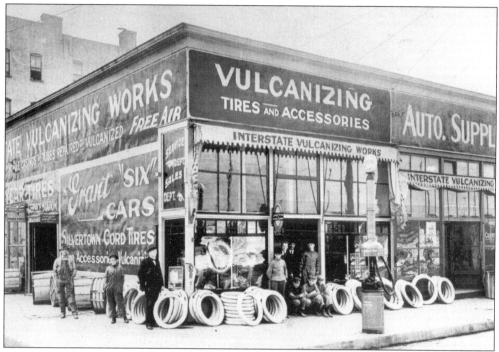

Interstate Vulcanizing at 407 Washington Street is shown here in 1910. Vulcanizing was a method of repairing inner tubes using heat and sulphur. The machine at the curb on the corner is a free air pump.

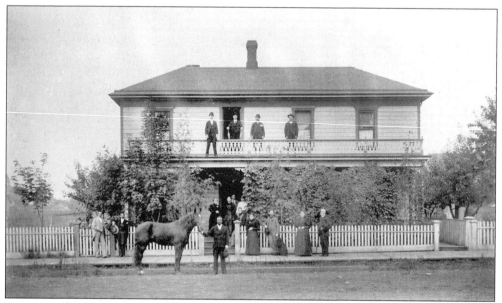

G.A. Bozarth's elegant boardinghouse was located at 511 West Ninth Street. As the city grew, many new boardinghouses were built and some homes were converted to that kind of business.

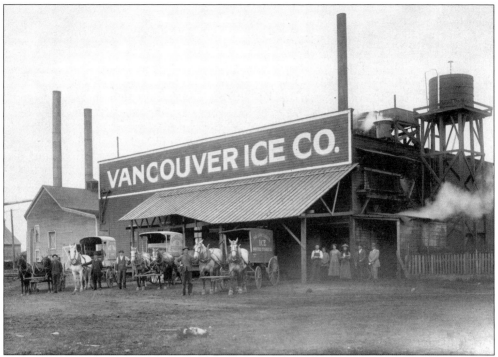

The Vancouver Ice and Cold Storage plant was established in 1904 at the foot of Seventh Street. Here, delivery wagons line up in 1910.

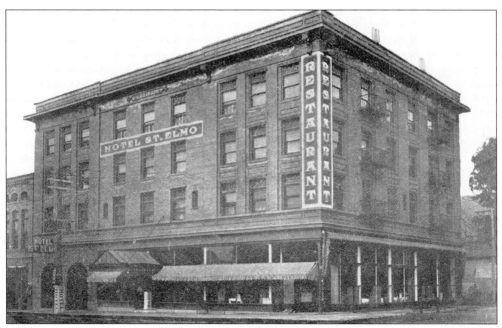

The Hotel St. Elmo's stood at Fifth and Washington for many years. It began as an elegant stopping place on the main road, and gradually became a working man's hotel, then deteriorated until it was demolished for the freeway. This picture was taken in 1911.

This view looks east from Sixth and Main Streets toward the railroad bridge. A wagon and team crosses on Washington Street traveling north from the ferry landing.

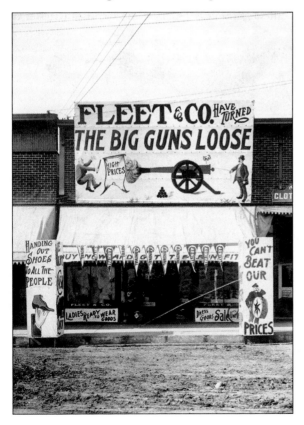

Advertising, advertising! The Fleet Company had just bought out the Swank Lady's wear in 1911 and wanted to tell the world. This photo was taken on Main Street at Ninth.

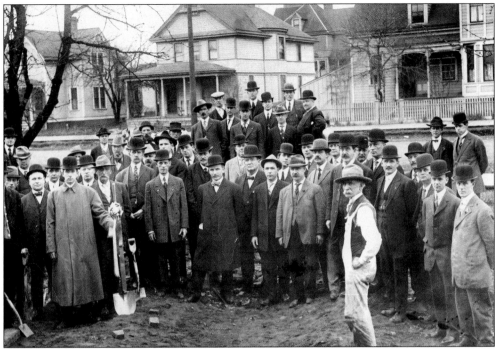

In March 1910 the brothers of the Elks Lodge gathered to break ground for their new lodge at Tenth and Main Streets. The building still stands and is listed on the National Register of Historic Places.

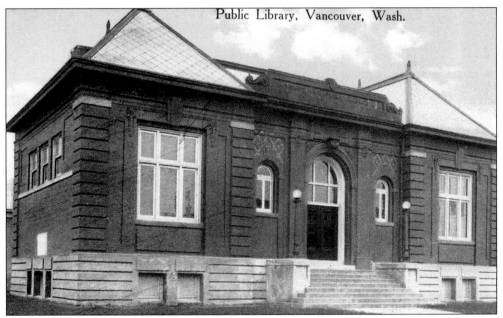

Public Library, Vancouver, Wash.

The Carnegie Library opened on New Year's Eve, 1909. The opening was held at night so that folks could experience the electric lights, and around 200 people showed up. This was the first public building so equipped. Of course, they didn't trust the new-fangled invention, so gas lights were also installed.

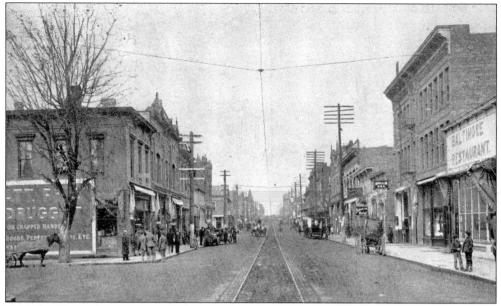

If you had been standing in the middle of Main Street in 1911 and looking north from Third Street, you would have seen cars beginning to replace horses and wagons. Here, streetcar lines run down the middle of the street under the wires that propelled them.

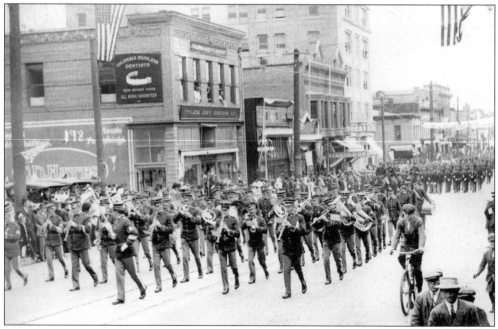

Another major Fourth of July celebration was held in 1911, with 600 men from the 1st Infantry and 1st Infantry band marching past Seventh Street on Main Street.

Many private individuals started up electric companies. Harry Burgy (on the left in straw hat) founded the Burgy Electric Works at 606 Main Street.

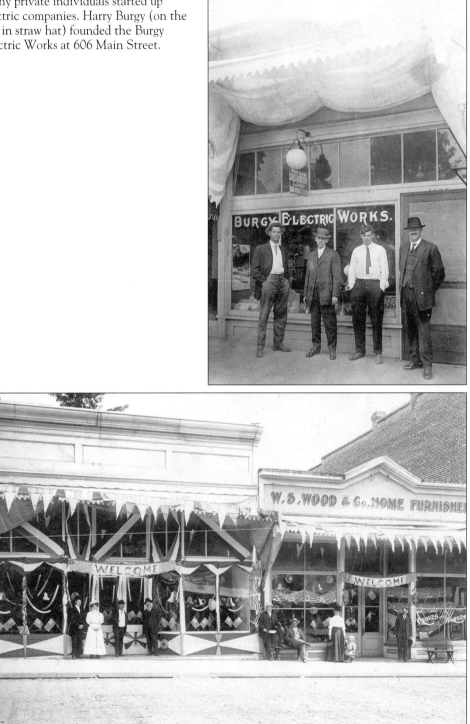

W.S. Wood and Company was located at Sixth and Main Streets. Later Wood added an auction yard and adopted the title "Colonel." W.S. Wood and his wife are shown on the far left.

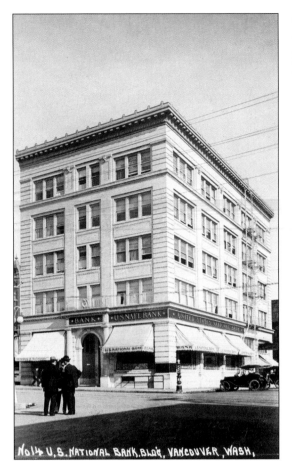

The U.S. National Bank was built in the Chicago style in 1914. Now fully restored, the structure still stands at Fifth and Main Streets and is known as the Heritage Building.

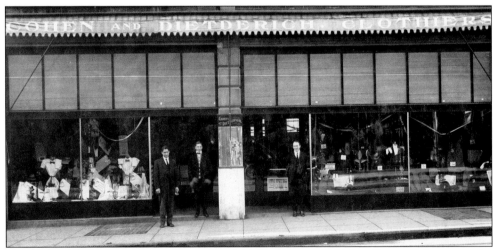

Pictured in front of Cohen and Dieterich's Clothing Store at 508 Main Street, Cohen is on the left and Dieterich on the right. The mirror on the building, right in the center, allowed folks to check their stylishness. The cameraman and his camera are visible in the reflection.

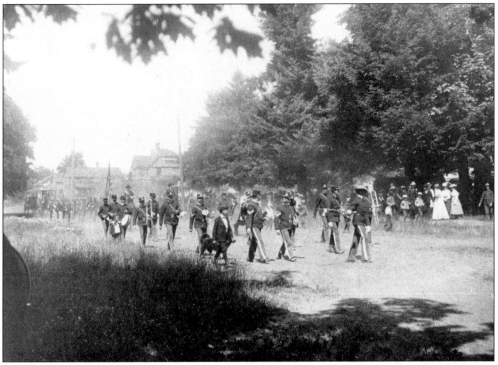

Sgt. Maj. Joseph White, a Buffalo Soldier who stood well over six feet tall, leads the Grand Army of the Republic into Esther Short Park on the Fourth of July, 1914.

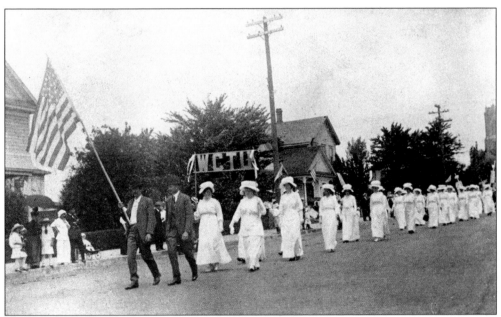

The ladies of the Women's Christian Temperance Union march all in white in the 1914 Independence Day Parade. The movement towards the prohibition of liquor was gathering momentum at this time.

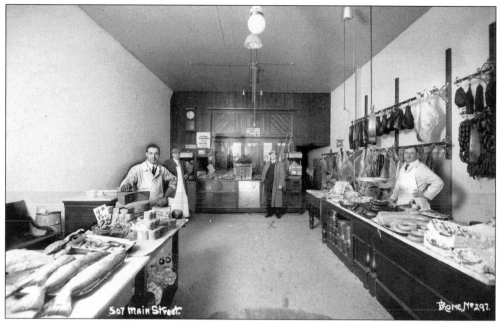

Will Miller and Bill Surber are shown here in Miller's Butcher Shop at 507 Main. Large salmon are spread out on a tray at the left; oysters are four pounds for 25¢.

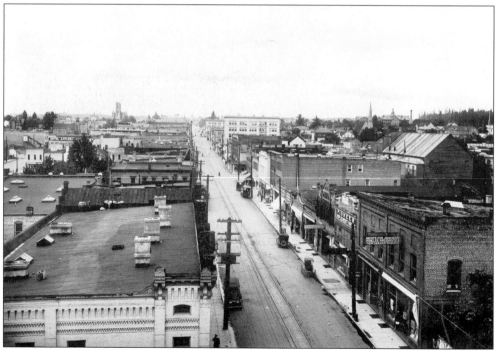

Rapid growth is apparent in this 1915 view of Main Street. The new U.S. National Bank rises in the mid-distance, St. James is in the skyline at the left, and Providence Academy is visible on the right. The reserve is still forested.

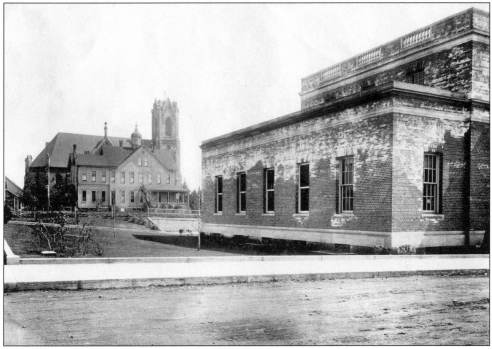

The new U.S. Post Office on Daniels was under construction in 1916. Behind it is the old rectory, and beyond that is St. James Church.

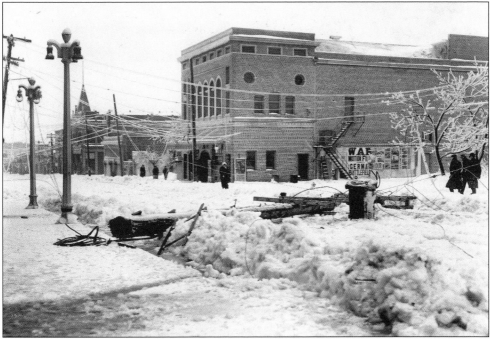

In 1916, a deep freeze left the wires over Main Street hanging low with ice. This theater (viewed from Ninth) was screening a movie about the German actions in the "Great War." The theater still stands and today houses a children's shop.

Everyone turned out for the 1916 Fourth of July parade. The Elks Lodge entered the parade in this patriotically decorated landau, proving that the parades were getting more elaborate.

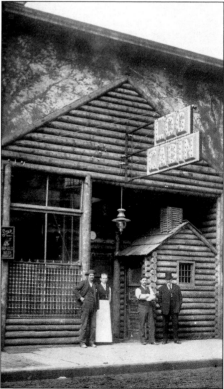

The most popular hangout in town was Luthlie's Log Cabin Saloon, which operated at 502 Main Street until Prohibition shut it down.

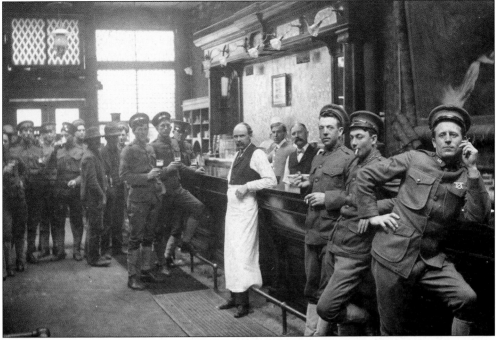

The Log Cabin Saloon catered to the U.S. Army. Here soldiers from the barracks relax with beers and smokes. It would not be long before the nation entered World War I.

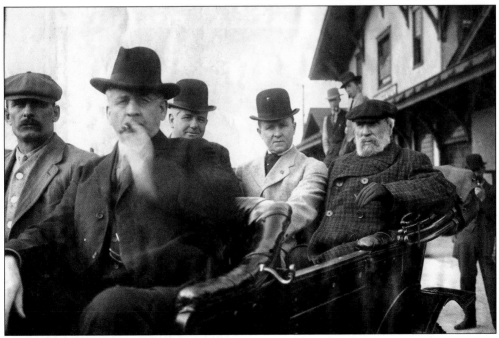

Mayor Joseph Kiggins, in the derby hat and light-colored coat, served as mayor, councilmember, and county commissioner. He would hold one office or another for 30 years. Here he meets railway magnate James Hill at the railroad depot on October 4, 1911 on his way to the dedication of the new county fairgrounds at Fourth Plain and Burnt Bridge Creek.

St. Joseph's Hospital was built in 1911 to replace the little hospital that had been founded by Mother Joseph. Located at Twelfth Street and West Reserve, that little hospital is now under the freeway. Meanwhile St. Joseph's grew into the present-day Southwest Washington Medical Center.

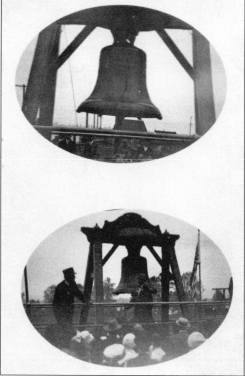

The Liberty Bell toured the United States in 1915. When it reached Vancouver, 2,500 people turned out to see it. These images are from a postcard circulated in town; it is the only record found depicting the Liberty Bell's visit to Vancouver.

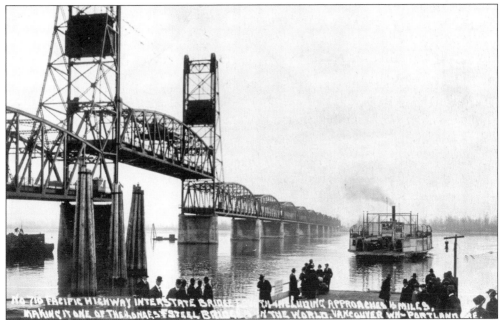

No. 710 PACIFIC HIGHWAY INTERSTATE BRIDGE WITH THE LUDING APPROACHES 4 MILES, MAKING IT ONE OF THE LONGES T STEEL BRIDGES IN THE WORLD. VANCOUVER WN - PORTLAND ORE.

Vancouver struggled long and hard to get a road bridge to Oregon. In the end it was built by the two counties, Clark in Washington and Multnomah in Oregon. On February 14, 1917, the first cars crossed the bridge, and the ferry boat made its last run.

The Daughters of the American Revolution donated and dedicated a monument in 1916 to the Spirit of the Trail. When the bridge was finished, the monument was placed at the end of it. When the freeway was widened, the monument was removed and permanently placed at the Clark County Museum at Sixteenth and Main Streets. The DAR again did the honors.

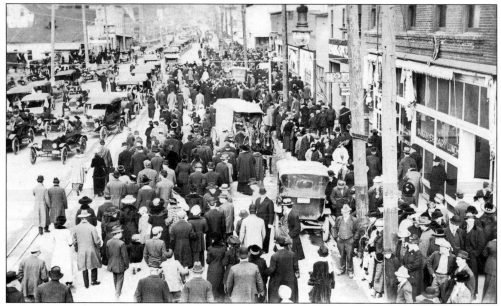

Pedestrians and cars line up to cross the bridge on opening day. It would be a toll bridge until it was purchased by the two states.

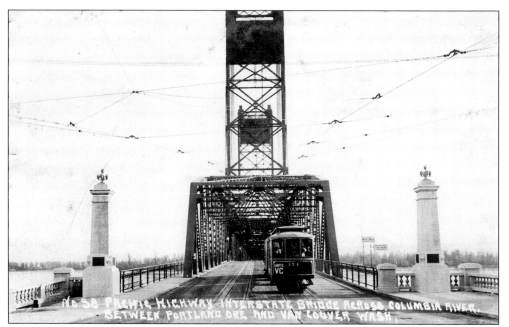

Twin obelisks guard each end of the bridge. The one on the Washington side carries a quote from John Ruskin: "Therefore when we build let us think that we build forever. Let it not be for present delight, nor for present use alone. Let it be such work as our descendants will thank us for. And let us think as we lay stone on stone that a time is to come when those stones will be held sacred because our hands have touched them and that men will say as they look upon the labor and wrought substance of, 'See this our fathers did for us'."

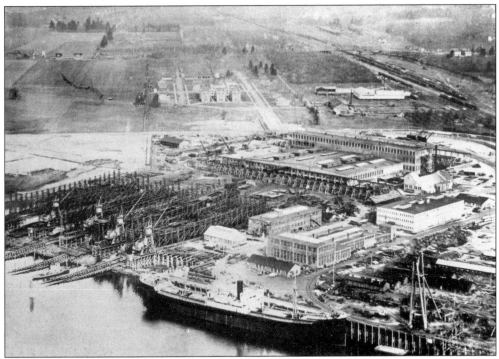

During World War I there were three shipyards west of the Interstate Bridge. This aerial view shows the Standifer shipyard, the largest of the three. The road leading away to the north is Simpson Avenue in Fruit Valley. The new Liberty Court Apartments stand just outside of the yards.

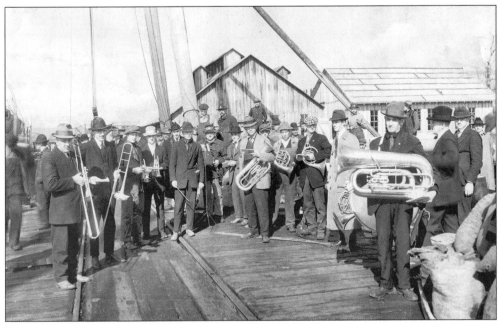

The Standifer shipyard band, shown here standing on the dock, played for each launching and to entertain visiting dignitaries.

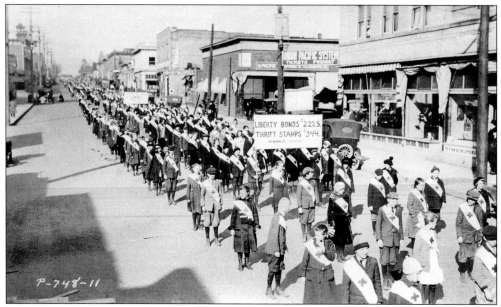

Schoolchildren march down Main Street, passing Eighth Street, in a Liberty Bond rally parade during World War I. Everyone was urged to buy bonds to finance the war. Some banks had to add extra help to handle the sales.

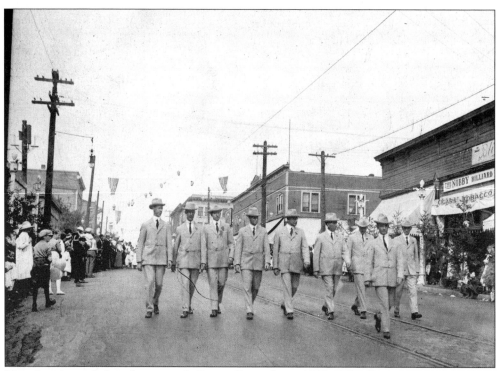

The decade ended with a grand Prune Festival in 1919. The Prunarians, community ambassadors and boosters, marched down the street in their white suits adorned with prune patches. They proclaimed Vancouver "Prune Capitol [*sic*] of the World."

Seven

THE 1920S AND 1930S

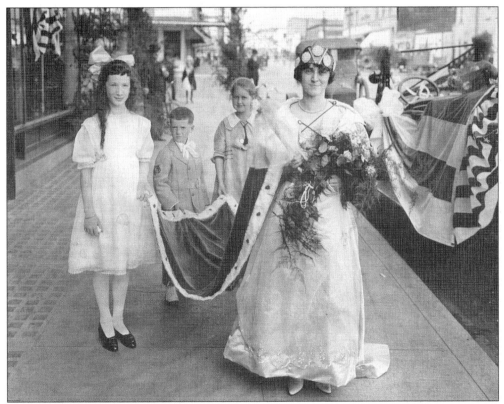

The Queen of Prunaria poses outside of her royal coach with her court. The queen was Fay Varic, and her court, from left to right, included Josephine Donovan, Richard Kirchburger, and Jane Parrish Brown.

The year 1920 began with an ill omen: 21 inches of snow in Vancouver and the thermometer plunging to minus 17 degrees at the guardhouse at the barracks. Hard winters continued through the decade with the river freezing over frequently. The prune industry was hit hard and, in fact, these were exceedingly hard times for everyone.

The Spruce Production Division was gone; the shipyards' lives were coming to an end. The brewery was used for soda bottling or cold storage. The jobs were gone. Potatoes were selling for $5 a sack and most restaurants stopped buying them.

It was a lawless era, with reports of crime such as Vancouverites had never seen. For the first time, lawmen were killed. Deputy Wilfred Rorison, Prohibition agents Edward Vlasich and Ballard Turner, and Sheriff Lester Wood would all die during the decade while enforcing the Volstead Act. Some must have felt that truly their world was coming to an end.

The Ku Klux Klan made its first appearance on March 11, 1922. At first it was quite respectable, representing itself as a pro-American organization. Many prominent people openly belonged. Only the American Legion opposed it. The Klan was a political force for several years, and a cross burning at Bagley Downs drew an audience of 10,000.

In 1925 Vancouver celebrated its centennial. It almost didn't happen due to a lack of money and interest. Finally two events were held: a parade in March and a pageant in August. The U.S. Mint in San Francisco minted 50,000 half dollars for the centennial with Dr. John McLoughlin's portrait on the face. Oakley Kelly flew the first batch into Vancouver where they were offered for sale as a fund-raiser. Not many were sold, and those that weren't were melted down. Check your change, they're very valuable now.

On December 23, 1925 Gov. Louis Hart signed legislation finally correcting the spelling of Clark County, one of his last acts at the end of his term.

The Pioneer Mother Statue in Esther Short Park was sculpted by Avard Fairbanks. The artist was present when it was unveiled on July 21, 1929.

October 29 saw the Wall Street crash and the beginning of the Depression. Mayor Kiggins surprised everyone by ordering the construction of a new city hall. "Build it as an office building," he said. "We might have to sell it in a hurry." It was dedicated on October 23, 1930.

Prohibition ended in 1932. A party to celebrate was planned but there was no beer in town. The brewery would not reopen until 1933.

The biggest news in 1937 was the landing of the Chkalov flight. On June 10, 1937, Valeri Chkalov piloted the March of Stalin into Pearson Field, ending the first transpolar flight from Moscow to the United States. There was war in Europe as the decade ended; all wondered if America would be drawn into it.

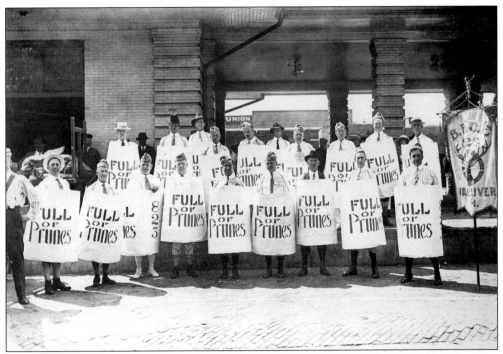

The Vancouver Elks Lodge carries the message of the Prune Capital of the World at the state convention in Yakima.

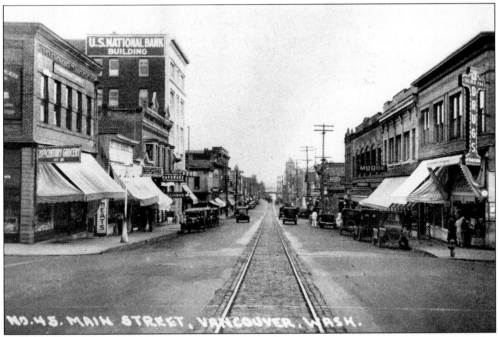

A view of Main Street in 1920, looking south from Seventh Street, shows the Interstate Bridge rising in the background. Cars dominate the scene now, and no horses are visible. Prohibition is in effect, saloons and taverns have vanished, and the brewery has shut down.

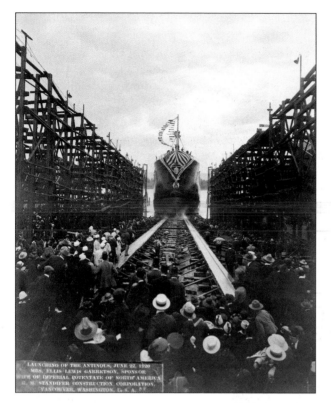

The *Antinous* was launched by the Standifer shipyard on June 22, 1922 although the shipyard was nearing the end of its life. A large Shriner's emblem decorates the prow of the ship. There was a Shriner's convention in town, and the wife of the imperial potentate, Mrs. Ellis Garretson, performed the ceremonial launching.

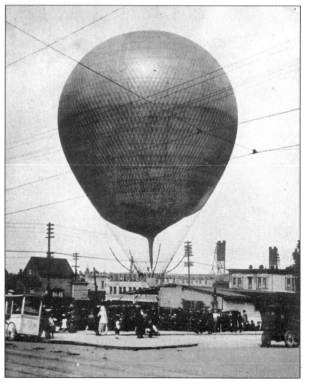

A demonstration of hot air ballooning captured everyone's attention on this summer day in 1922. The balloon rose across the street from Esther Short Park on Sixth Street.

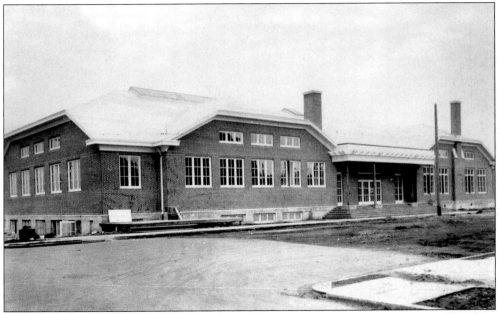

The American Legion Memorial Building, shown here on October 31, 1922, was an important part of downtown life for many years. There was a swimming pool, meeting rooms, and later a teen center. Vancouver City Hall occupies the site today.

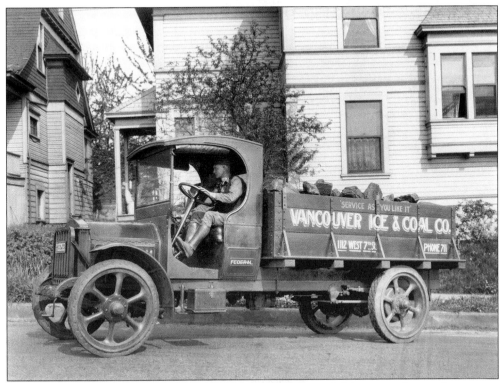

Homes and businesses were heated with wood or coal. This coal delivery truck served customers in 1924.

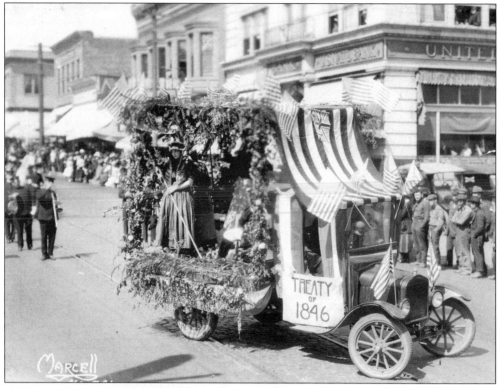

The centennial in 1925 had two celebrations: a parade in March and a pageant in August. A great fair had been proposed, but the idea was abandoned due to a lack of money and a lack of interest. This wonderful float, turning onto Sixth from Main Street, celebrates the Treaty of 1846, which made Washington an American territory.

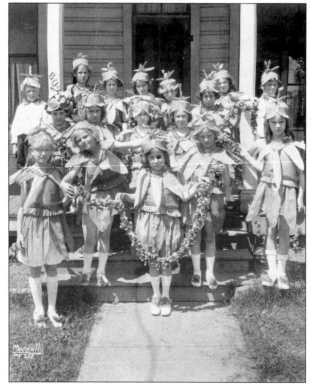

Schoolchildren participate in the flower pageant for the centennial. While the two boys in the upper left and right do not look particularly pleased to be there, the little girl front and center has a magnificent black eye.

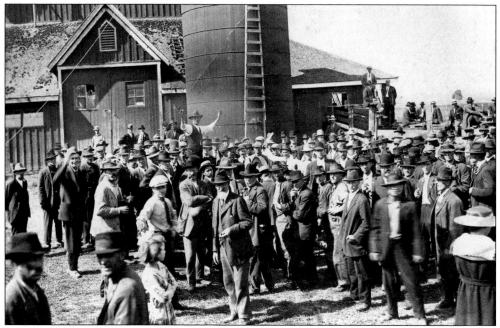

"Colonel" W.S. Wood conducts an auction at the edge of town. His furniture store operated at 201 East Fifth Street. Wood's son Lester was elected sheriff in 1926 and died in a gun battle with moonshiner Luther Baker on May 22, 1927. Baker was hung at Walla Walla for the crime. Lester Wood was the only elected sheriff to die in the line of duty, and Colonel Wood never recovered from the death of his son.

March 17, 1928 was a grand day in Vancouver when the new Evergreen Hotel at Fifth and Main Streets was opened. Its construction was a community effort, with bonds sold by the chamber of commerce to raise funds. On the same day, the governor of the Hudson's Bay Company in London pressed a telegraph key to activate a street lighting system that lit Vancouver from Third to Tenth Streets, "flooding the area with light."

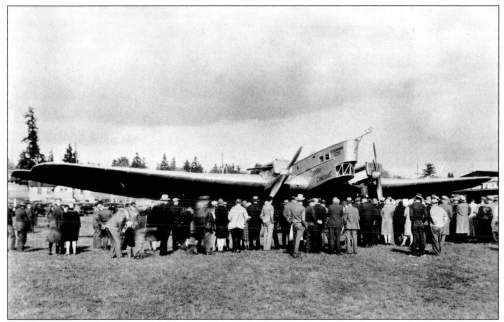

Four Russian pilots made an unexpected landing at Pearson field on October 18, 1929. Their plane, the "Land of the Soviets" was making a goodwill flight across the United States when it developed engine trouble and dropped in for repairs.

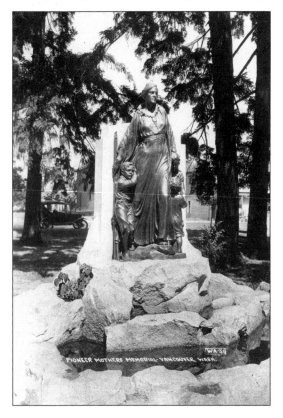

The Pioneer Mother in Esther Short Park was created by prominent sculptor Avard Fairbanks (1897–1987) and dedicated on July 22, 1929. Many of his works adorn Latter Day Saints temples around the world. He also designed the ram hood ornament for Dodge and the winged mermaid for Plymouth.

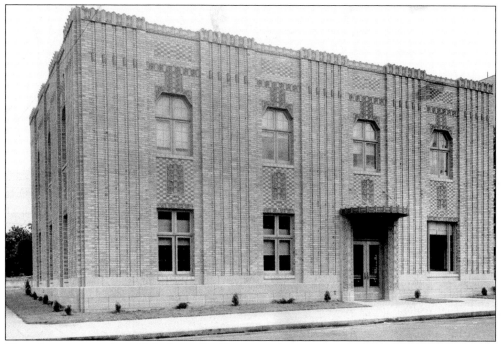

The charming art deco Telephone Building, on the corner of Eleventh and Washington Streets, is listed on the National Register of Historic Places. When it was opened on June 15, 1935 locals knew they had created a special place. The opening celebration lasted for three full days.

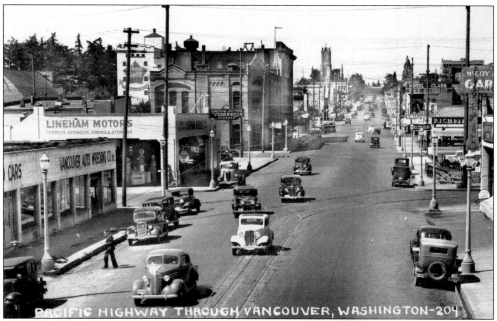

A view of Washington Street in 1936 reveals that most of the businesses were now automobile related. St. James's steeple rises on the skyline in the center. The brewery, now Hop Gold Beer, is visible at center left. Esther Short Park is still forested.

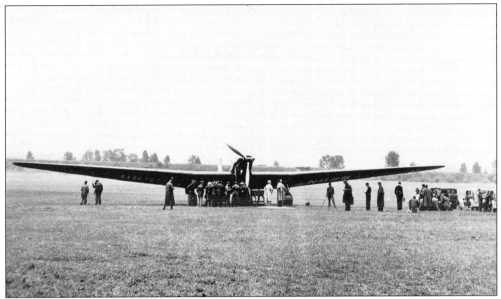

On June 20, 1937 a huge aircraft floated in over the Interstate Bridge. Vancouverites knew what it was; they'd been following the progress of the ANT25 en route from Moscow to San Francisco as it made the first transpolar flight.

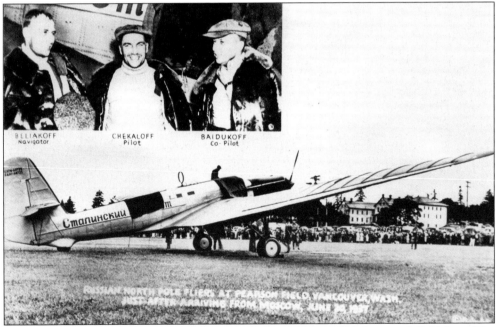

This postcard shows the three Soviet airmen, Valeri Chkalov, Beliakov, and Baidukov. The Alaskan mountains were higher than anticipated, and they hadn't enough fuel to make it to San Francisco. Remembering Lindbergh's reception in Paris, they chose to set down at a military field.

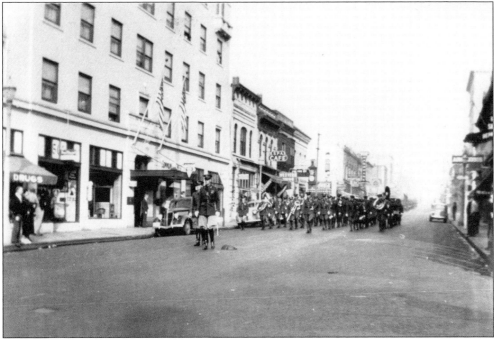

A military parade was held to welcome the Russian airmen. Here, the tribute passes the Evergreen Hotel on Main Street.

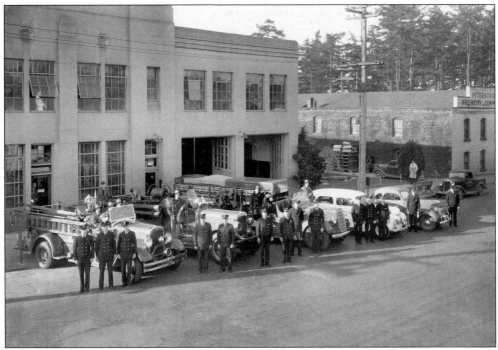

When city hall was built in 1930, Mayor Kiggins said, "Build it like an office building in case we have to sell it in a hurry." Here, the 1939 fire department poses on the Eighth Street side of the building. Pierre DuPaul was the chief.

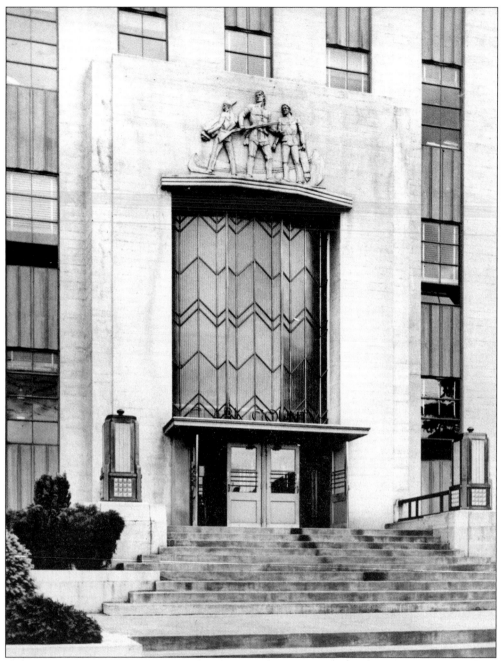

The county courthouse was the first concrete building in Clark County, opening on October 20, 1941. The architect, Day Hillborn, included a sculpture of the "voyageurs" over the entrance door. In an unfortunate attempt at remodeling, the sculpture was removed. Public outcry led to a new bronze sculpture being cast and subsequently installed.

Eight

THE WAR YEARS

This Main Street photo from the 1940s shows Runyans Jewelry at Seventh and Main Streets and Reders Drugs across the street. KVAN Radio operated from the second floor, where Willie Nelson would soon broadcast as a disc jockey.

The 1940s began with a clear signal that the Depression was ending. Hydroelectric dams on the Columbia provided cheap electric power. In 1940 Alcoa opened its factory and began pouring aluminum ingots from its great pots. A new, modern courthouse was built. The brewery was in full swing again, and the barracks were preparing for the war that was sure to come. On December 7, 1941 news of Pearl Harbor hit, and the expectation was fulfilled.

In February Henry Kaiser began to build his shipyards on the Hidden farm at Ryan's Point, and by July the yards were in full operation. Thousands of people from all over the country began arriving for work. By 1944 over 36,000 people were working at the yards—more than the total population of Vancouver before the war.

These newcomers needed homes, and the Vancouver Housing Authority was formed in response. It built six wartime cities just outside of town: Fruit Valley, Ogden Meadows, Fourth Plain Village, Bagley Downs, Burton Homes, and the biggest wartime development west of New York, McLoughlin Heights. D. Elwood Caples, the attorney for the authority, announced that the Fair Housing Act would be enforced. The next folks in would get the next housing, regardless of race or religion. A city that had had few people of color integrated as the houses were occupied.

Vancouver boomed as never before, becoming a 24-hour-a-day city. New businesses opened. Wages were high, and people had money to spend. With rationing in effect, there wasn't much to spend it on. Except war bonds. As they had done during World War I, people crowded into the banks to buy bonds. Schoolchildren bought savings stamps in class. Thousands of soldiers passed through the barracks and came into town for last flings before shipping out. Restaurants, bars and night clubs thrived.

As the war drew to a close, the shipyards and Alcoa began to cut back. What would happen to all those jobs? Kaiser proposed an aircraft factory, saying he would barge the craft across the river to the Portland airport. That didn't work. Then he built the first Kaiser automobile in Vancouver, but the car was ultimately built in Michigan. Kaiser shut down and Vancouver's population began to dwindle.

In the spring of 1948, the river began its usual spring freshet, but this time it rose higher and higher. Winter had left a deep snow pack in the mountains. Now it was upon the city. Across the river, the town of Vanport huddled behind its levees. On May 31, 1948 a railroad dike gave way. Water rushed into the town, sweeping it away forever. Many came to Vancouver to be sheltered in wartime housing. The water rose almost to the underside of the Interstate Bridge. Sandbags held it off from downtown.

The Vancouver Housing Authority looked at the wartime housing and realized the city would be surrounded by the biggest slum west of New York if they didn't act. Taking out a 20-year mortgage for $80,000 the authority bought McLoughlin Heights. The houses came down; the area was replanned and sold. The mortgage was retired in 18 months.

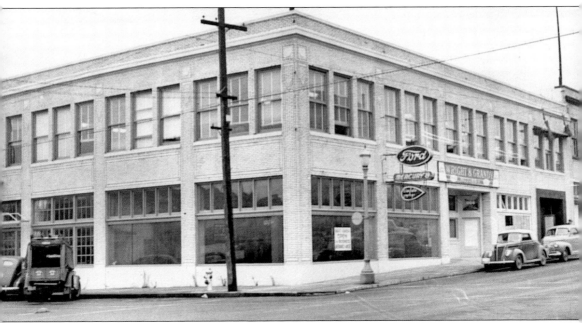

The Marine Building at Washington and Tenth Streets was occupied by Wright and Grandy; later it was Marshall Ford. It is now the Vancouver Marketplace with shops and restaurants.

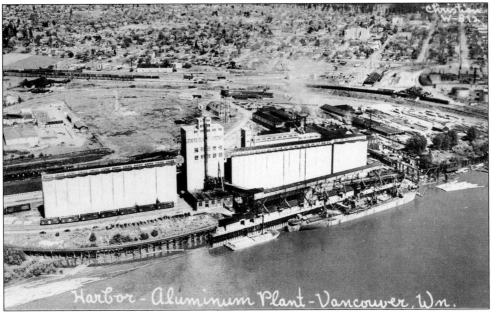

Power was turned on at the Alcoa plant for the first time on September 2, 1940. The plant was west of downtown, on the riverfront. Cheap power from Bonneville Dam attracted the company to Vancouver.

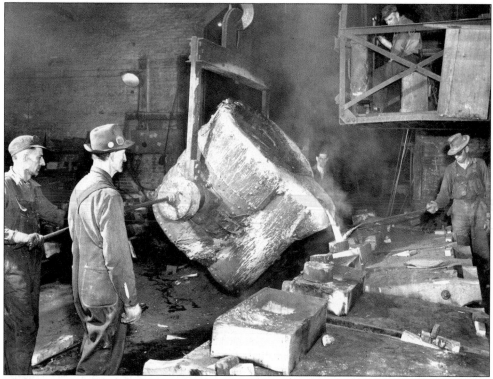

The first aluminum pig, or ingot, was poured from pots like these on September 23, 1940.

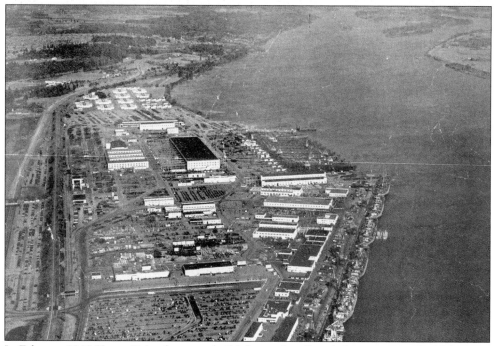

In February 1942 Henry Kaiser began to build shipyards at Ryan's Point next to the U.S. Army reserve. The shipyards were turning out ships before they were finished in July.

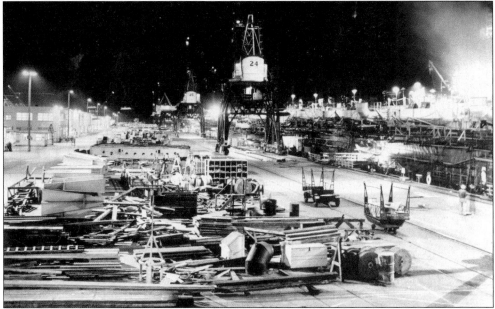

The shipyards ran 24 hours a day, 7 days a week, building Liberty ships, baby flat tops, and two dry docks. The remaining buildings are now incorporated into the Columbia Business Park. A viewing tower stands at the east border where visitors can look down on the old shipways.

Vancouver built six wartime cities outside of the then city limits to house workers: Fruit Valley, Fourth Plain Village, Bagley Downs, Ogden Meadows, Burton Homes, and the biggest of them all, McLoughlin Heights. The population soared from roughly 18,000 to 85,000 in just a few months.

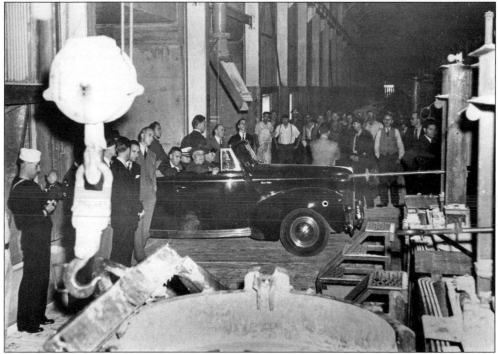

Franklin D. Roosevelt paid a surprise visit to Vancouver in November 1942. He toured Alcoa by driving into the plant.

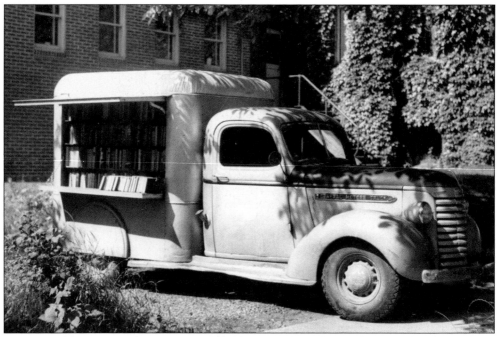

Vancouver librarian Eva Santee convinced the army to loan this truck, parked here behind the library c. 1944, to be used as a bookmobile. After the war, the police stopped the driver and found that the truck still belonged to the army. Eva had to go to the jail and bail him out.

During the war, radio was the most popular form of home entertainment. Vern's Radio and Repair, located at 105 West Seventh Street, kept tubes and parts in stock for repairs.

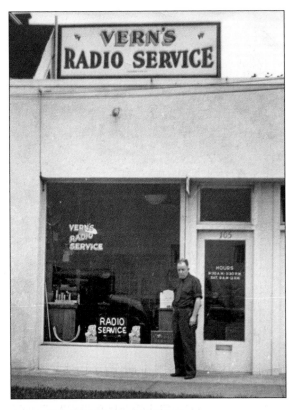

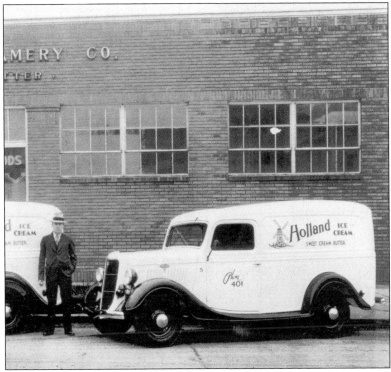

Jacob Propstra stands by his creamery and delivery trucks. The Holland Creamery was taken over by Jacob's son George, who turned the creamery into the Holland Restaurant and then opened Burgerville hamburger stands, now ubiquitous in the Northwest.

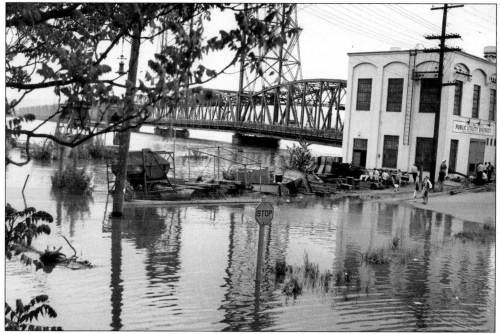

This photo, taken on Memorial Day 1948, shows that high water has undermined a railroad trestle on the Oregon side of the river. The town of Vanport, built for the Kaiser workers, was totally destroyed. On the Vancouver side, Fruit Valley was inundated, and Lower Columbia, by the Public Power Building, was submerged.

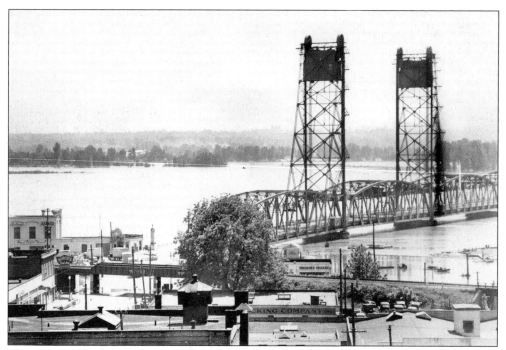

The Interstate Bridge barely clears the water on May 31, 1948. The bridge was closed, and many Vancouverites were forced to cross the railroad bridge on foot to get home.

Nine

AFTER THE WAR

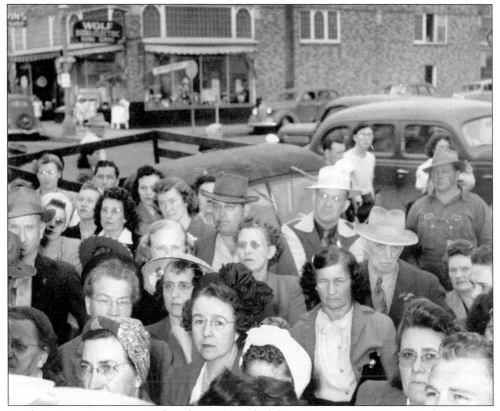

A television set in a store window draws a crowd of the curious on Main Street in the 1950s.

Vancouver started the 1950s by doubling in size when, on New Year's Day, McLoughlin Heights was annexed into the city.

With the Korean War in full swing, the barracks were active, but the shipyards were gone. Vancouver's population began the same downward spiral that had occurred after World War I. Likewise, businesses began to fail.

On June 14, 1952 the National Association for the Advancement of Colored People held its first meeting in Vancouver. Before World War II, only one African-American resident was recorded, Charles Kimbro. With the shipyards hiring, Vancouver soon had 2,000.

The Interstate Freeway system reached the city in the 1950s. To everyone's dismay, the plans called for closing Fifth Street, the main highway to Walla Walla. In spite of protests, the closure was made, and the freeway formally opened on March 31, 1955. Gov. Arthur Langlie cut the ribbon as Vancouver opened the great chasm that cut through the city.

The second span of the Interstate Bridge opened in July 1958. There were bands, fly-overs by jets, and howitzer salutes. The old bridge was immediately closed for rebuilding.

On August 15, 1955 Secretary of the Interior Douglas McKay dedicated the historic site of Fort Vancouver as a national monument. The way was set for rebuilding, and roads were extended across the barracks.

The city's population continued to slump. The new freeway encouraged development further north and the business district began to shift.

On Columbus Day 1962 the fiercest windstorm ever experienced blasted Vancouver with winds estimated at over 90 miles an hour. Million of dollars of damage was incurred. Fortunately, there were no deaths.

In 1965 urban renewal came to Vancouver. As with many other cities, this often meant urban removal. Acres of structures were cleared to make room for light industrial development. The community rallied to save the Slocum House, the home of Charles Slocum, a prominent early businessman. It was moved to Esther Short Park where it now serves as a theater.

A boy on a bike hero-worships two firefighters on their rig in front of Al's Auto Service at 212 West Eighth Street in this 1947 view.

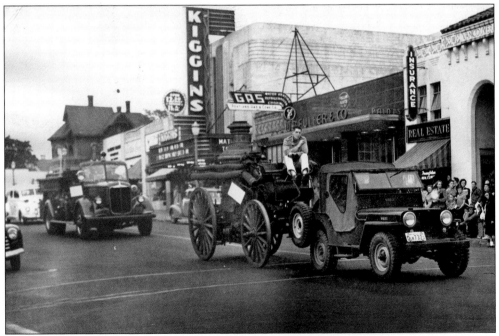

The fire department turned out its antique pumper, pulled by a jeep, during this 1948 parade to welcome home heroine Gretchen Fraser. Fraser won gold medals during the winter Olympics in Oslo, Norway, in the ladies downhill and slalom.

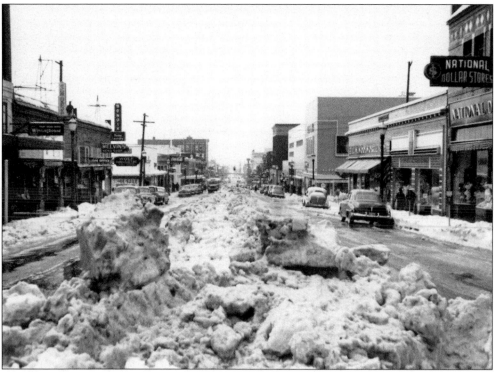

The 1950s began with ice and snow. On January 21, 1950 the streets were sufficiently cleared for shoppers on Main Street to visit Woolworth's, the Nation Dollar Stores, and Hoffman's clothing. With close to 80,000 people living near downtown, the city had a bustling center.

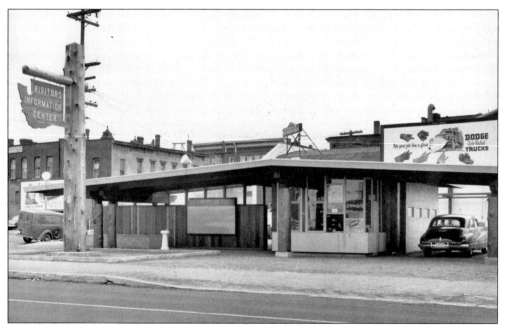

A new visitor center was opened on Washington Street in 1950. It was staffed by volunteers who handed out maps and brochures for all of western Washington.

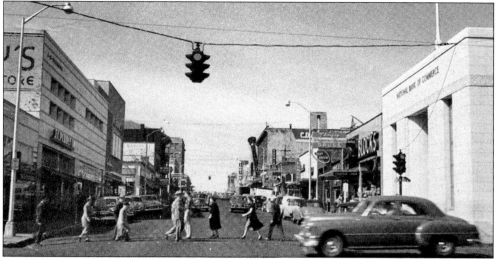

People in town still argue over where J.C. Penney's was located. In this 1951 photo the store is on the west side of Main Street at Eighth. Shortly it would move to the east side of the street at Tenth.

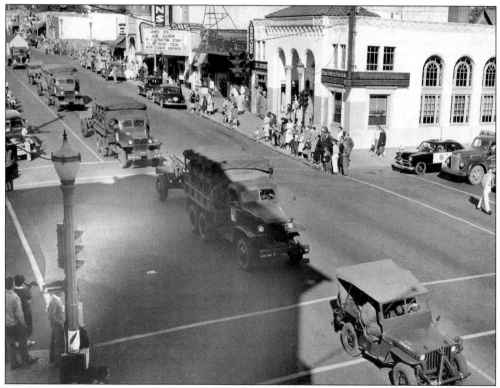

The Cenaqua began on August 16, 1950 to celebrate the 175th anniversary of Fort Vancouver. Here the army parades at Tenth and Main Streets. The Kiggins Theater is showing *The Stratton Story* as evidenced by its new marquee. The Vancouver Federal Bank still has its arches, although they would be removed and the building obscured with fieldstone until 2002, when it was restored.

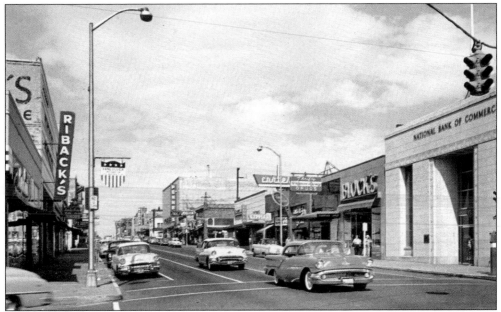

This photo of Main Street in 1958 shows a placard on a sign post proclaiming Vancouver an All-American City. Vancouver received that award in 1958 and again in 1987. Penney's is now at Tenth Street.

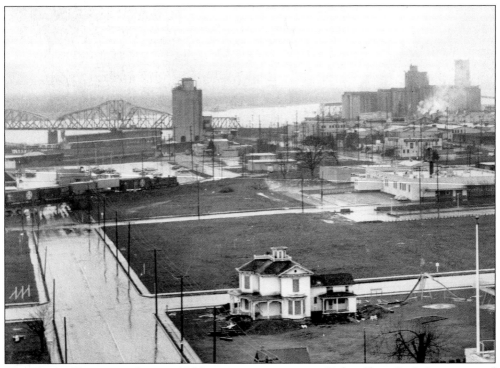

The Slocum House, seen here in 1966, rests at its new site in Esther Short Park. It was moved just two blocks from its original location to save it during urban renewal.

Disease had killed many of the old firs in Esther Short Park and now the Columbus Day storm struck in 1962 with winds in excess of 90 miles per hour, marking the end of the park's forest.

This photo immortalizes the end of an era. Many of the buildings at the shipyards were destroyed on October 15, 1958. Those remaining have been incorporated into Columbia Business Park.

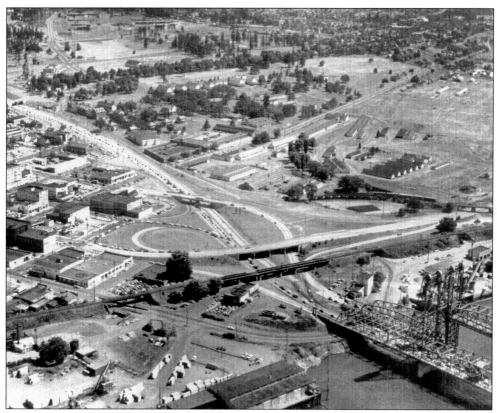

The second span of the Interstate Bridge opened on July 1, 1958. The northbound span was promptly closed to rebuild it with a hump to match the new span.

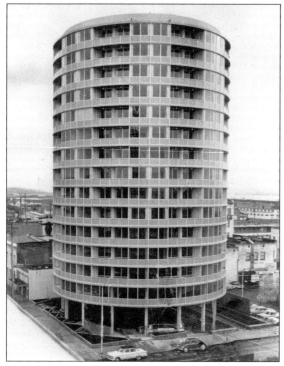

Smith Tower, Vancouver's high rise at Sixth and Washington Streets, went up in 1965. Named for W.R. Smith, the president of the founding corporation, it was called "the can that Lucky Lager came in" by Vancouverites not accustomed to round buildings

At the height of the Cold War era, Vancouver celebrated the Soviet Transpolar Flight of 1937 by dedicating the Chkalov Monument on June 20, 1975. A street in the east part of town was named Chkalov Drive. There was nothing there then, but Chkalov's son Igor believed that it would be an important street someday.

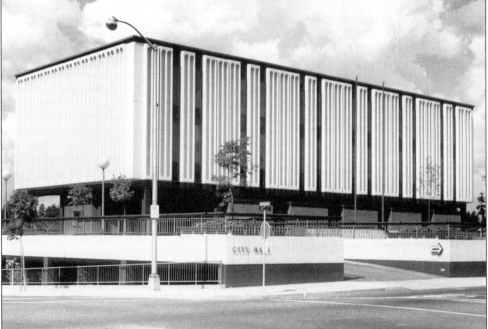

A flurry of construction in 1968 gave Vancouver a new city hall (pictured here), a new police station, Marshall Pool, and the Luepke Senior Center.

George Goodrich, owner of several restaurants around town, opened the Inn at the Quay, a steakhouse right on the river in 1972. Later a hotel was added.

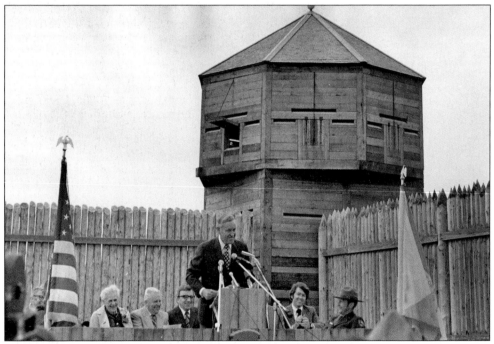

Oregon governor Tom McCall speaks at the dedication of the newly reconstructed Fort Vancouver on April 19, 1975. Many years of dedicated effort by Vancouver citizens and the help of Congresswoman Julia Butler Hansen (to McCall's right) enabled the return of the Hudson's Bay glory.

Ten

THE 1980S AND 1990S

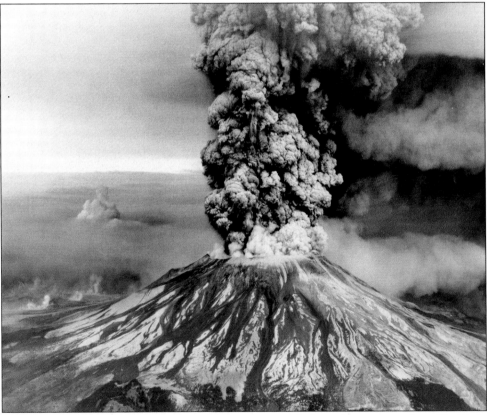

On May 18, 1980 the U.S. Geological Survey received the radio message from David A. Johnson, "Vancouver, Vancouver, this is it!" that signaled the eruption of Mount St. Helens. Johnson was never found. The mountain that had marked the skyline for centuries was suddenly gone, replaced by a truncated mound.

The decade began with rumbling as Mount. St. Helens awoke. United States Geological Survey personnel began to arrive. Then a tiny black spot appeared in the sparkling snow of the mountain. Everyone laughed at this tiny eruption and went back to ignoring her. On the morning of May 18, 1980, the USGS received a final radio message from its man on the mountain, David A. Johnson: "Vancouver, Vancouver, this is it!" He was six miles from the mountain. The skies were clear when suddenly a horrific mushroom of roiling black smoke rose toward the stratosphere. David Johnson was never found. The USGS Volcano Observatory in Vancouver is named for him.

The National Geographic Society had hired a talented young Columbian newspaper photographer, newlywed Reid Blackburn, to photograph the volcano. Those photos never came back down the mountain; Blackburn's melted camera was found in his car next to him.

In the city, the federal government held out the lure of ownership of Officers' Row and immediately a grassroots effort by the people of the city was launched to save it. The Congressional delegation was peppered with letters and salted with phone calls until they surrendered. The deed was presented to the city in 1984. Rehabilitation began and "the Row" was rededicated in 1988.

On August 22, 1985 the city received the shocking news that the General Brewing Corporation would cease brewing beer at its Vancouver brewery the next day. Vancouver had operated a brewery there since 1854, but now the abandoned brewery would blight downtown for many years until the city finally bought and demolished it.

A grand exhibit in 1987 celebrated the 50th anniversary of the Chkalov flight, which also spurred interest in preserving Pearson Field. A group of citizens formed a historical society and created the Pearson Air Museum in 1989. Later a grant enabled the restoration of the original 1911 hangar and the opening of the Murdoch Air Museum at Pearson Field.

The Marshall Lecture Series began with Forrest Pogue, the biographer of Gen. George C. Marshall in 1988. Since then, several distinguished people have been invited to speak on the principles that General Marshall exemplified. The speakers have included Gen. Colin Powell, Secretary of State Madeleine Albright, Tom Brokaw, Sen. Daniel Inouye, and other noted leaders.

The Congressional Medal of Honor Society chose Vancouver as the site of its 1991 convention. General Powell arrived to greet the recipients, as did Vice President Dan Quayle. The recipients of the medal dedicated a monument to the four Medal of Honor recipients who lie in the Post Cemetery: Herman Pfisterer, Moses Williams, William McCammon, and James M. Hill. That event also marked the beginning of Celebrate Freedom, the way Vancouver now observes each national holiday,

Vancouver began to grow, turning around decades of decline. Today its riverfront, ignored for decades, boasts trails, residences, and new businesses. Esther Short Park, once grown old and dreary, now sparkles with flowers, a bandstand, and Propstra Plaza with its brick clock tower. The park is surrounded with new buildings. Today the young people say they're "goin' to the 'Couv'." And when you have a nickname, you know you've made it.

Reid Blackburn, a talented young photographer from the *Columbian* newspaper was photographing Mount St. Helens for *National Geographic*. He perished in the blast.

One of Reid Blackburn's photographs is of the railroad depot. He could find poetry in the most mundane objects.

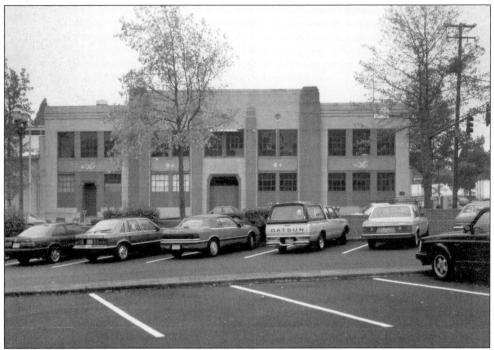

This is the last photo of the Lucky Lager Brewery. Having been an eyesore for 10 years, the city bought the abandoned brewery in 1992 and began demolition. The new Vancouver Centre buildings stand on the site today.

In 1991 Vancouver hosted the Congressional Medal of Honor Society. Here, the Medal of Honor recipients begin the parade held in their honor. Warrant Officer Dan Jollota counts cadence behind the banner.

Mayor Bruce Hagensen walks with Gen. Colin Powell from the Marshall House. General Powell was to greet the medal recipients and then deliver the Marshall Lecture. (Photo by Cliff Barbour.)

At the foot of Columbia Street near the river stands the monument to the city's namesake, George Vancouver. The sculpture represents his ship, the *Discovery*, and the Columbia River.

In 2002 Sen. Daniel Inouye of Hawaii, a Medal of Honor recipient, came to Vancouver to deliver the Marshall Lecture. He visited the Marshall House and was greeted by Royce Pollard, Vancouver's longest serving mayor, and Congressman Brian Baird. (Photo by Cliff Barbour.)

Thousands attend the many concerts and festivals in the new Esther Short Park.

The bell tower at Esther Short Park has 40 bells that play and mark the hours. It was a gift to the city from George Propstra, the founder of the Burgerville hamburger chain. Waterfalls cascade down all four sides of the tower as bronze salmon leap up from below. Twice daily, doors open and figures emerge to tell the salmon legend.

As a thank you to George Propstra, sculptor Jim Demetro made this touching scene of a child handing a flower to a gentleman sitting on a bench in Esther Short Park. The newspaper on his lap is the *Columbian* announcing the dedication of the clock tower.

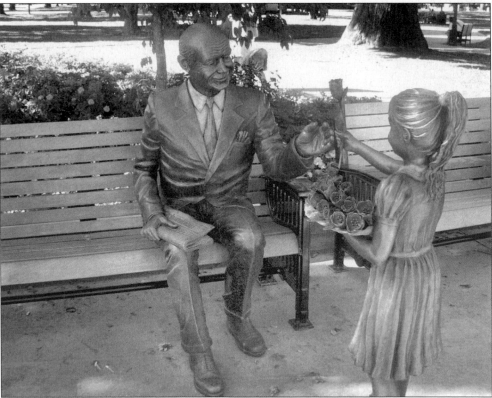

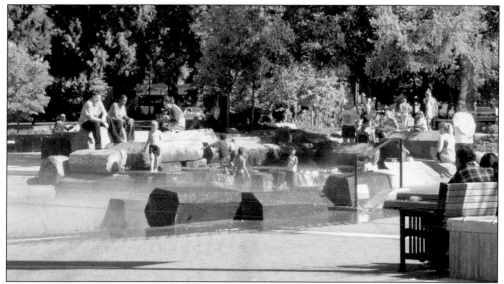

Basalt columns and water spray entice children to play in Esther Short Park by the bell tower.

This new hotel and conference center across from the tower anchors downtown to the park.